Drawing Comics Lab

Drawing Comics Lab

Characters, Panels, Storytelling, Publishing, and Professional Practices

Robyn Chapman

Quarry Books
100 Cummings Center, Suite 406L
Beverly, MA 01915

quarrybooks.com • craftside.typepad.com

First published in the United States of America by
Quarry Books, a member of
Quayside Publishing Group
100 Cummings Center
Suite 406-L
Beverly, Massachusetts 01915-6101
Telephone: (978) 282-9590
Fax: (978) 283-2742
www.quarrybooks.com
Visit www.Craftside.Typepad.com for a behind-the-scenes peek at our crafty world!

Library of Congress Cataloging-in-Publication Data

Chapman, Robyn.
 Drawing comics lab : characters, panels, storytelling, publishing, and professional practices / Robyn Chapman.
 pages cm
 1. Comic books, strips, etc.--Technique. 2. Drawing--Technique. 3. Comic books, strips, etc.--Authorship. I. Title.
 NC1764.C48 2012
 741.5'1--dc23
 2012017704

ISBN: 978-1-59253-812-6

Digital edition published in 2012
eISBN: 978-1-61058-629-0

10 9 8 7 6 5 4 3 2 1

Book Layout: *tabula rasa* graphic design, www.trgraphicdesign.com
Series Design: John Hall Design Group, www.johnhalldesign.com
Photography: Rebecca Greenfield
Cover Art: top, Robyn Chapman; left, Vanessa Davis; middle, Tom Hart;
right back, James Strum; right front, Robyn Chapman

Printed in China

Dedication

To James Sturm and Michelle Ollie, founders of
the Center for Cartoon Studies, who taught me a little
about cartooning and a lot about being a grown-up.

Contents

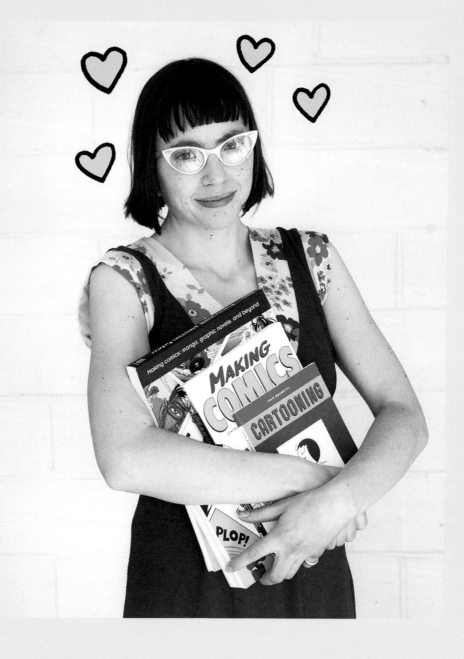

About This Book

IF YOU WANT TO BE A STUDENT of the comics medium (and if you're reading this, I'm guessing you do), then you're living in a good age. There has never been a better time to learn how to make comics. Today there are about a half-dozen colleges in the United States where you can earn a degree in cartooning, and there are several more where you can enroll in a class or a course of study. For the do-it-yourself student, there are even more options—in the past decade the publishing market has been flooded with instructional cartooning books—and look, here's one more! Many, perhaps most, of these books have a fairly superficial approach to cartooning, treating it as a drawing style instead of the unique storytelling medium that it is. This is nothing new; it's how the art world has considered comics for years (if it bothered to consider it at all). There are two books that were early exceptions that I must call out. They are Will Eisner's 1985 *Comics and Sequential Art* and Scott McCloud's 1993 *Understanding Comics*. These books were truly innovative because they weren't about how to draw comics, but how to *think* about comics. I have tried to incorporate some of this approach. Although this book is titled *Drawing Comics Lab*, it's as much about thinking, design, and writing as it is about drawing.

The exercises in this book are meant to jump-start your creativity and guide you toward effective ways to tell stories visually. I've had the good fortune to be student, peer, and friend to many remarkable cartoonists over the years. They've taught me a lot, and I've patched it together into this book.

I offer this book as a starting point for exploration; it is not meant to be a treatise on the entire comics medium. If you are looking for a complete, all-in-one course in cartooning, I can recommend two books: *Making Comics* by Scott McCloud and *Drawing Words and Writing Pictures* by Jessica Abel and Matt Madden. As I wrote this book I found these tomes invaluable. Ivan Brunetti's *Cartooning: Philosophy and Practice* is a brilliant book and I highly recommend it for the more advanced cartoonist. Brunetti's sophisticated insights and deeply felt truths might be a bit much for a complete novice (though a clever college student might take to it easily).

There is a lot of knowledge and a healthy dose of love in each of these books. I offer my endorsement and hearty thanks to each of the authors.

What We Mean When We Say "Comics"

It's nearly a prerequisite for an instructional cartooning book to spend a page or two defining what exactly a "comic" is—now it's my turn to give it a shot. Defining comics isn't easy. The terms we use are often misnomers that are misleading and misused. Here's a fun experiment: tell a new acquaintance that you are a cartoonist. Nine times out of ten, you'll have to spend a few minutes explaining what exactly that means.

And the truth is, there are no hard definitions that we all can agree on. Scott McCloud defines comics as "juxtaposed pictorial images in a deliberate sequence." Will Eisner preferred the term "sequential art." For me, the best definition I can come up with is this: when you put one picture next to another and a story happens, that's comics.

It's important to understand that when I use the word *comics*, I'm talking about the *medium of comics*. So when you come the across uncomfortable subject-verb paring of "comics is" instead of "comics are," know that a lazy copy editor is not to blame. Like Scott McCloud, I use the word *comics* to describe the art form, not the plural form of "comic book."

Within the medium of comics there are several different formats. Comic books are comics in pamphlet form, like (but not limited to) the superhero comics you can find at a comic book store. Comic strips are short-form serialized comics, like (but not limited to) the humor comics you can find in the newspaper or online. There is a lot of contention about what exactly a graphic novel is, but put simply it is a novel-length comic. Thankfully, you can find them just about everywhere these days: in bookstores, in libraries, and even on the *New York Times* best sellers list. These formats are all variations of the same big idea: putting one picture next to another to make a story happen.

I use the word *cartoonist* to describe a person who makes comics. It's what I prefer to call myself, and most of my peers share this preference. Some choose to call themselves comics artists, but that might suggest that they only draw comics, and don't write them. Some prefer the lofty title of graphic novelist, which is fine if what you truly are making are novel-length comics. *Cartoonist* works for me—it's an all-encompassing term that is comfortably honest and humble.

Now that we're all on the same page, let's stop quibbling about semantics and actually make some comics!

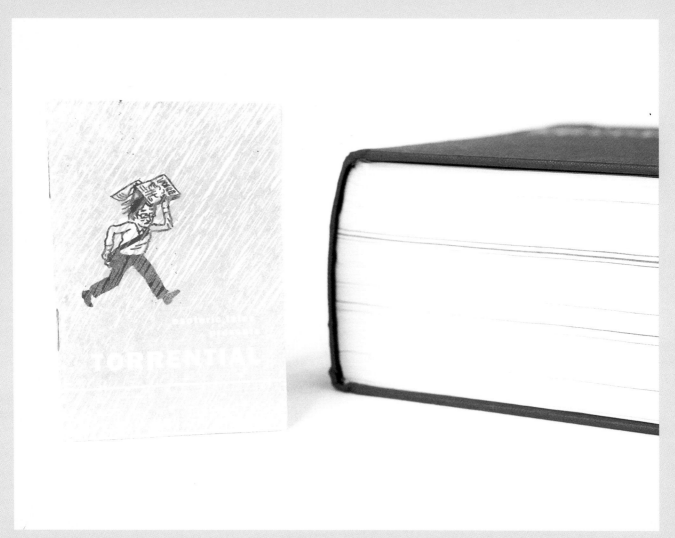

On the left, Torrential by Jonathan Bennett is a handmade minicomic measuring only 3 inches tall. On the right, Comix 2000, published by L'Association, is a dictionary-sized anthology with 2,000 pages of comics. Though they come in different packages, they're both comics.

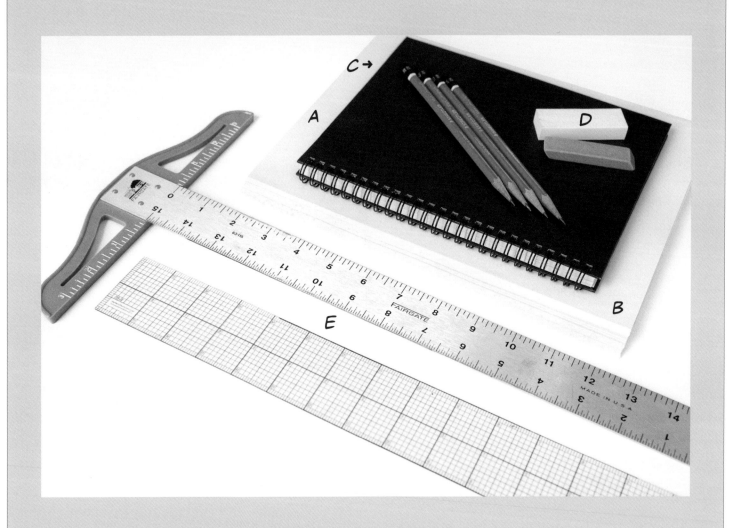

Basic Supplies

One of the great things about cartooning is it doesn't take much to get started. The art supplies are simple and relatively cheap. In theory, you could make a comic using the everyday office supplies you have lying around the house—Art Speigelman's *Maus* was drawn with a fountain pen and typewriter paper, after all. You don't want low-quality art supplies working against you, however. Here is a basic list of tried-and-true tools that you'll likely find useful as a cartoonist. We will go into these tools in greater detail in Unit 4.

Sketchbook (A)

Any kind is fine—a fancy hardcover journal or a cheap sketchpad will work. Pick one you'll feel comfortable drawing in and that you can take with you wherever you go.

Copy Paper (B)

Many of these exercises start with doodles, and there's no reason to use fancy paper for that. Buy a ream of cheap letter-size paper that is designed for a photocopy machine, and keep it handy.

Drawing Pencils (C)

Pencils come with graphite in different degrees of hardness, with 9H being very hard and light, and 9B being very soft and dark. You'll probably want a pencil in the H spectrum (a 2H is my personal favorite).

Erasers (D)

A white plastic eraser is best for comics pages. Pink erasers are good, too, though a little more abrasive.

Rulers (E)

A T-square is essential. Look for a high-quality aluminum one that is at least 15 inches (38 cm) long. A clear plastic ruler will come in handy, too.

Drafting Tape or Artist's Tape (F)

These are low-tack adhesives, and if used carefully they can be removed from paper without damaging the surface.

Porous-tip Pens (G)

These are the disposable drawing pens you'll find in any art supply store. Pitt pens or Micron Pigma pens are good, dependable brands.

Corrective White (H)

Wite-Out pens are handy. Pro White, a brand of opaque watercolor, works well, too. White gouache is my preferred corrective white because its smooth texture is easy to ink over.

India Ink (I)

Look for India ink that's labeled waterproof and avoid cheap brands that are too watery or gray. Winsor & Newton and Speedball are old standbys.

Brush (J)

Buy yourself a round watercolor brush with sable hair. Synthetic hair or sable synthetic hybrids can work well, too. The cartoonist brush of choice is the Winsor & Newton Series 7 in a size 2.

Nibs (K)

There are a lot of varieties out there, but the Hunt 102 or Crow Quill is a great starter nib. Make sure you get the hollow-body nib holder that will fit it.

Bristol Board (L)

This is the thick, durable paper most cartoonists use. It comes in either smooth or vellum, which is a textured surface.

Tracing Paper (M)

Tracing paper is great tool for refining drawings. Tracing vellum is a heavy-duty tracing paper that offers a sturdier surface and can be used for inking.

Light Box (not shown)

Depending on how you pencil, this may be a very handy tool. There are several large, bright, and expensive light boxes on the market, but there are also some small cheap ones that can work in a pinch.

Drafting Table (not shown)

If you plan to spend a lot of time drawing, you may want to invest in a table that was designed for it. Drafting tables can be expensive, though. You may want to consider buying an angled tabletop drawing surface, or you can even build one.

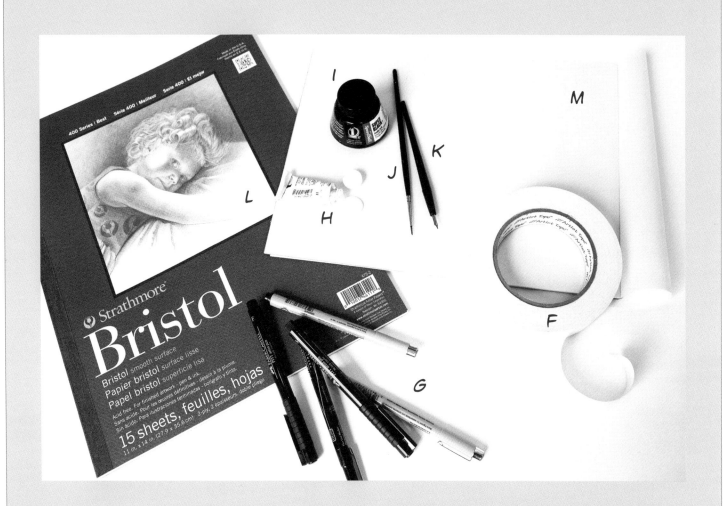

Drawing Comics Is Hard

It's labor, it's a chore, and it takes hours and hours. Drawing an entire graphic novel? Don't even get me started! Or rather, don't get *you* started. If you're a beginner or an emerging cartoonist (and that's who will benefit the most from this book), then you really don't need to be worried about making graphic novels yet. Don't be duped into thinking that graphic novels are the only kind of comics that matter. What defines a graphic novel is largely a matter of binding—as cartoonist Jeffrey Lewis put it, graphic novels are just comic books without the staples. For the beginning cartoonist, exercises and short stories are the way to go. That's what you'll find in this book.

Drawing Comics Can Be Fun

And it should be fun, at least most of the time. Sure, there will be plenty of times when drawing comics feels like work, drudgery even. But deep down that work should be fun. If it's not, you're doing something wrong (and I should know, because I've spent years doing it wrong). I think it's far more important to find joy and satisfaction in the comics you create than to be professional or even "good." Comics that are made from a place of joy, inspiration, and truth will be far more interesting than comics that are simply drawn well. Regardless of what types of comics you make, if they're fueled by your own ambition and vision, then they are, by their very nature, personal works. Good comics, even professional comics, usually follow this sort of creative process, but they rarely precede it. In other words, if you're a beginner cartoonist who is asking, "How do I make a career in comics?" not only are you putting the cart before the horse, but you're also pretty much guaranteeing that horse is going to be miserable. Create from a place of joy and follow through to the end. Several years down the road, and hundreds of comic pages later, you might discover that you've made a career in comics. And you might not. That's okay, too.

You've Got Character

TO TELL A GOOD STORY, you need to know your characters well. Any good writer is familiar with their characters' desires, histories, and weaknesses. Cartoonists need to know this, too, but they also need to know the shade of the character's head, the curve of his spine, or the way that she smiles. Sketching your characters, over and over, is one way to get to know them well.

When you first draw a character, it probably won't go quite right. That's okay—you've only just met. Good relationships grow over time. As you sketch your characters, not only will you get a better understanding of what they look like, but you'll also get a better understanding of who they are.

Building Characters

Materials

Materials

- paper
- pencil
- pen

Have you ever looked at the crisp lines in a comic book and wondered: How did they do that? How did they get the lines to look just right? Chances are, the cartoonist did a lot of underdrawing. Underdrawing is a sketching method. Using lines and basic shapes, you will quickly doodle a character. Refine the drawing by erasing the mistakes. The ink line goes last, and you only ink the lines you want.

Tips of the Trade

Don't worry if your underdrawing looks sloppy. Sometimes, you have to draw a lot of bad lines to the find the good ones.

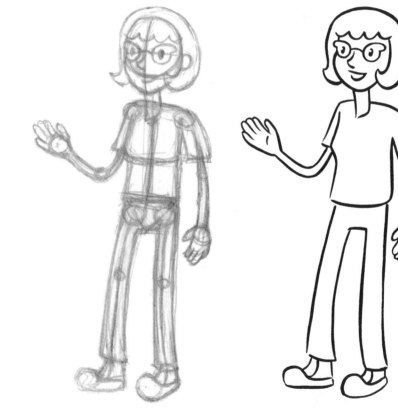

Let's Go!

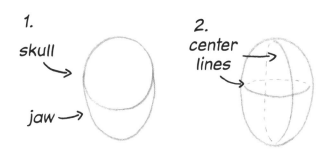

1.
skull →
jaw →

2.
center lines →

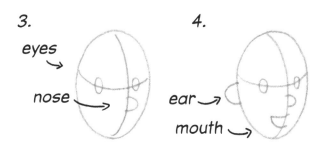

3.
eyes →
nose →

4.
ear →
mouth →

Drawing cartoon characters is a lot easier if you start with basic shapes. Building your drawing from shapes will ensure that it appears three-dimensional. And your character will look more consistent, panel to panel, if you always use the same building blocks to start your drawing.

1. Start with a circle. Think of this circle as the skull of your character's face. Next, you need to draw the jaw. I have made my jaw an oval shape. You could use another shape, like a triangle or a square. Pick the shape that is best for your character.

2. Draw two center lines across your face: one horizontal and one vertical. I have decided to draw this character in a three-quarter view, so the vertical center line is on the right side of the face.

 Think of your drawing as a three-dimensional object, not as lines on paper. Your center lines should follow the contour of the face. Drawing your center lines is like drawing lines across the surface of an egg.

3. Your center lines are guideposts that tell you where to draw the features of your face. Eyes fall in the center of the face, so I place them on my horizontal center line. I place the nose on the vertical center line.

4. Place other details like ears, mouth, and hair. Pay attention to how these details relate to one another. For example, the top of my character's ear lines up with her eyes; the bottom of her ear lines up with her nose. Every time I draw her, I make sure the ears line up the same way.

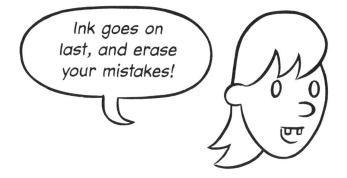

Ink goes on last, and erase your mistakes!

Tips of the Trade

If your underdrawing is too scribbly it can be difficult to ink. Over-penciling can tear up the surface of your paper, and too much graphite on your paper keeps ink from adhering. Consider using a light box or a piece of tracing paper to ink your underdrawing. I used tracing vellum, a heavy-duty type of tracing paper, to ink many of the drawings in this book.

Model Sheets

- paper
- pencil
- T-square
- pen

"Characters are more important than jokes."

—Bill Watterson

Now that you've drawn a head, your character needs a body. Did you know you can draw a body in three simple lines?

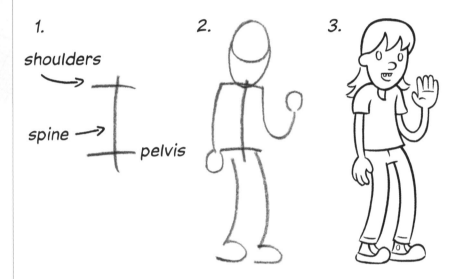

1.
shoulders
spine
pelvis

2.

3.

Let's Go!

1. Start with a vertical line for the spine. Add a horizontal line for the shoulders and a horizontal line for the pelvis. Draw these lines quickly to capture the gesture of the body. Don't think too hard about this step. Quick, spontaneous lines can make your drawings come alive.

2. Build on top of your lines. Create legs and arms using simple lines. Use circles for the hands, feet, and joints.

3. Refine your drawing by adding more details and erasing mistakes.

Let's Go! (continued)

You've drawn a full figure, but you're not done yet! To better understand your character as a three-dimensional shape, try drawing a model sheet. A model sheet shows a single character in multiple positions. It's a very handy tool for cartoonists and animators.

1. Draw your character in a standing position, facing you. Using your T-square, draw horizontal lines at key points in the figure's anatomy, like the top of the head, the eyes, the chin, the hands, and the bottom of the feet. Make sure these lines extend across the page and that the anatomy lines up with the guidelines you've made.

2. Now draw your character again, but this time have her stand in a three-quarters position. Make sure her anatomy continues to line up with your guidelines.

3. The final step is the profile drawing. This step is the hardest one, because a profile looks so different from the front-facing position. Rely on your guidelines to keep all the anatomy in the right place.

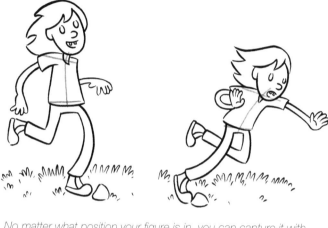

No matter what position your figure is in, you can capture it with three quick lines.

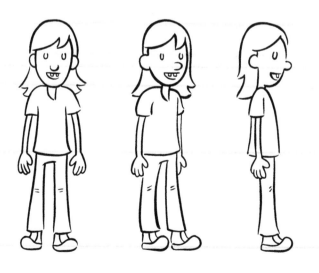

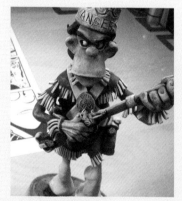
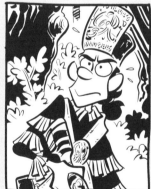

Tips of the Trade

Consider sculpting a clay model of your character so you can look at it from any angle. This model was made by cartoonist Chris Schweizer. Don't have the time to sculpt a prefect likeness? Put a kneaded eraser on the end of a pencil and sculpt a quick head.

Animals, Occupations, Emotions

- paper
- pencil
- a friend

"I don't see myself as a developer of art or style. I think of my lines on the page as a vocabulary."

—Will Eisner

Cartoonists use pictures to tell stories and convey information. When we read a comic, we decode this pictorial information in a way that's similar to how we read. The ability to "read" and "write" pictures is called visual literacy. Visual literacy is a vital part of cartooning. In fact, some cartoonists would argue that visual literacy is what cartooning is all about!

This exercise will help you flex your picture-writing muscles. It was created by James Sturm, the director of the Center for Cartoon Studies. On the next page you'll see examples drawn by James's students.

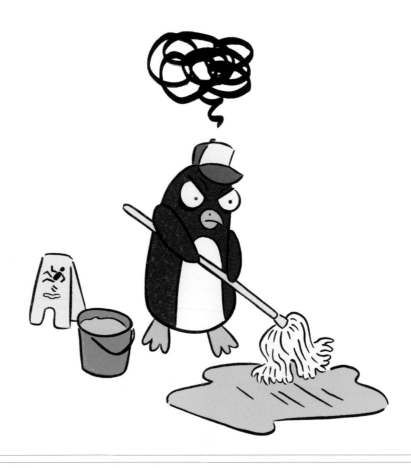

Let's Go!

1. Make of list of ten animals.

2. Make a list of ten occupations.

3. Make a list of ten emotions.

4. Circle one word from each list.

5. Combine those words into a single character (for example, the drawing on the left is a grumpy penguin janitor). Draw your character using images only, no words.

6. Show your drawing to a friend, without telling him any of the words you chose. Can he guess what your drawing is?

Did your friend guess correctly? If not, ask what was confusing about your drawing. By listening carefully to your friend's reaction, you will learn how to make pictures that "read" better.

Tips of the Trade

Did it make you uncomfortable to show your drawing to a friend? When participating in an art critique, try your best to absorb useful information without taking it too personally. My motto regarding art critiques is, "All reactions are true." Meaning, there is value in a sincere reaction to your art, whether you agree with it or not.

Visual literacy is a two-way street: you can learn a lot by reading images as well as by creating them. Can you guess what the animals below are? How did you come to your conclusions? What visual information are you picking up on? Check your guess against the answers below.

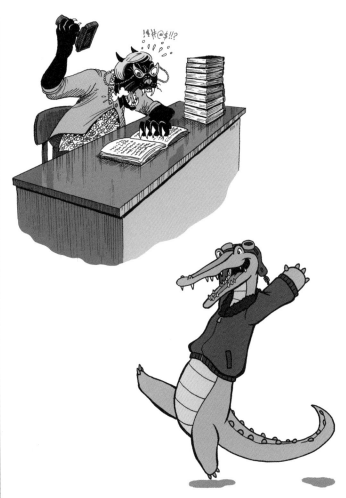

TOP: Furious panther librarian (art by Dakota McFadzean)
BOTTOM: Excited alligator pilot (art by Rachel Dukes)

LAB 4 Character Creation Intensive

- paper
- pen or pencil
- index cards
- scissors

"You must be in constant search for the characters and ideas that will eventually lead you to your best areas of work. The characters that you start out to draw today may not be the same characters that you will end up drawing a month or a year from now."

—Charles Schulz

photo by Seth Kushner

Our obsessions define us, and they can define our characters. If you're trying to create a new character but you find yourself stumped, an obsession will offer a good jumping-off point. We will explore this in our next exercise, which comes from Tom Hart, director of the Sequential Artists Workshop.

Like many of Tom's exercises, the Character Creation Intensive fosters a spontaneous approach to cartooning that's part beat poetry and part improv comedy. From the beats, Allen Ginsberg gave us the "first thought, best thought" method, which challenges writers to be spontaneous and fearless. From improv we have the method of "Yes, and", which challenges improvisators to take all offered ideas and then add their own. You'll find both philosophies in this exercise.

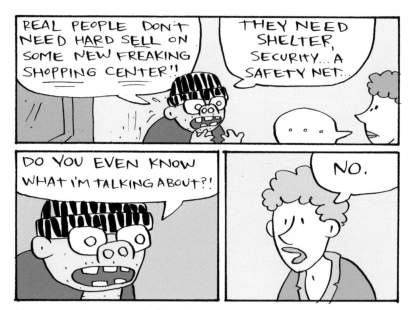

All comics on these pages by Tom Hart

Let's Go!

1. Grab your paper and write your reaction to the following prompts. Let the answers that pop up first be the ones that you write down.

 a. Write down the thing most distracting you away from this book at this moment (lost keys, spousal troubles, wars in your hemisphere, family drama, whatever).

 b. Write down something that generally obsesses you and focuses you, rather than distracting you (gardening, music, the state of the environment, the history of China, safety orange, etc.).

 c. Write down one thing you have a lot of information or opinions about, or something you're good at (knitting, train schedules, electronics, etc.).

2. Grab your index cards or a pile of scrap paper. You're going to quickly sketch several characters.

 a. Draw a self-portrait.

 b. Draw a self-portrait again, but this time draw yourself as if everything in your life had gone wrong. Would you be a bug, a lizard, a hobo, a weed? Let's call this your "low self."

 c. Draw another self-portrait, but make this one a perfect, awesome version of your life. Would you be an astronaut, a superhero, Dr. Manhattan? Let's call this your "high self."

 d. Draw any figure of authority.

 e. Draw a monster or real jerk.

 f. Give any one of these doodles a spouse or parent.

 g. Draw a complete innocent.

3. Grab your responses to the writing prompts. Pick some words or statements that you find interesting.

4. Take a piece of paper and draw at least five empty word balloons. Fill the balloons with the words or statements you selected.

5. Cut out the word balloons and place them over the heads of your characters. Try different balloons on different characters; see what feels right or seems interesting. What characters emerge?

This method of attaching and expanding may seem silly here, but it works equally well for graver stories or images. The characters and obsessions that you harbor will create their own fire.

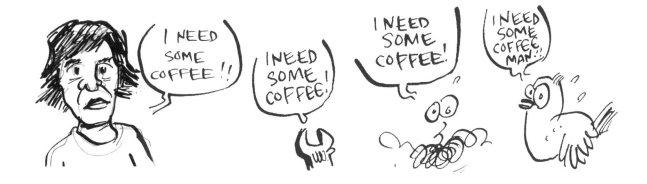

Materials

- paper
- pencil
- pen

"Comics are more an art of reading [rather] than looking."
—Chris Ware

Cartoonists fill their comics with lots of different characters. How will the reader tell them apart? The trick is to make the characters visually distinct. In this illustration, cartoonist Drew Weing painted fifty cats, each different. I'm only going to make you draw ten!

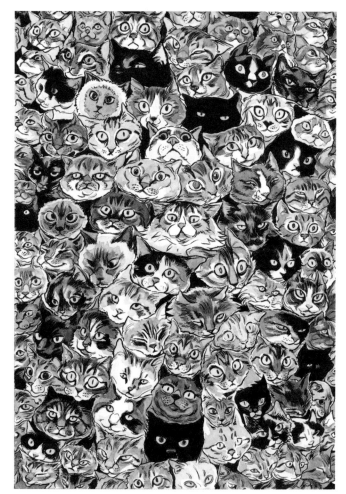

By Drew Weing

Let's Go!

1. Using basic shapes, quickly draw a cat (the head only). It might be helpful to think of a cat you know (I've drawn my pet cat Lulu). Your drawing doesn't have to be perfect; keep it simple and quick.

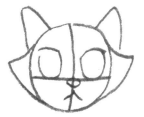

2. Now draw another cat. Consider changing the size and shape of the head and the placement and size of the eyes. Consider changing the color, texture, and pattern of the cat's fur.

What do these differences say about your cat's personality? In my second drawing, I've drawn my pet cat Marty. Lulu is sweet but a little dumb; Marty is smart but a little mean. Can you tell? I've given Lulu big eyes, placed low on her head. Marty has smaller eyes, and her fangs are showing.

3. Keep drawing cats until you reach ten!

 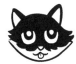

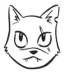 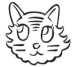 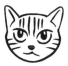

Tips of the Trade

An easy way to make your characters distinct is to make them different shapes and sizes. Bud Fisher's famous cartoon characters Mutt and Jeff are iconic because of their size. Mutt is tall; Jeff is short. Vaudeville fans were familiar with this sort of comedic duo. A difference in size made vaudevillians easy to distinguish from a distance (and often, they made the jokes funnier).

Life Drawing Comics

Materials

- sketchbook
- drawing tool of your choice
- a park or other public place

Whatever your comic is about, whether it's a space opera or a diary strip, I bet it stars people (or at least humanlike creatures). You will need to draw these people in a variety of positions and from a variety of angles. Drawing the figure from life is the best way to get comfortable with the human form. Life drawing can't be mastered in a single lesson—it's a lifelong practice for any ambitious artist. That's why a sketchbook is an essential supply for any cartoonist.

Katherine Roy sketches in public compulsively, and these sketches inform her comics. By carefully studying people, she understands not only how they look but also how they move, feel, and act.

Tip

Life drawing can't be mastered in a single lesson—it's a lifelong practice for any ambitious artist.

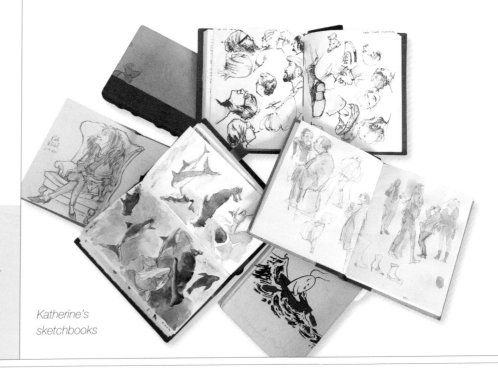

Katherine's sketchbooks

Let's Go!

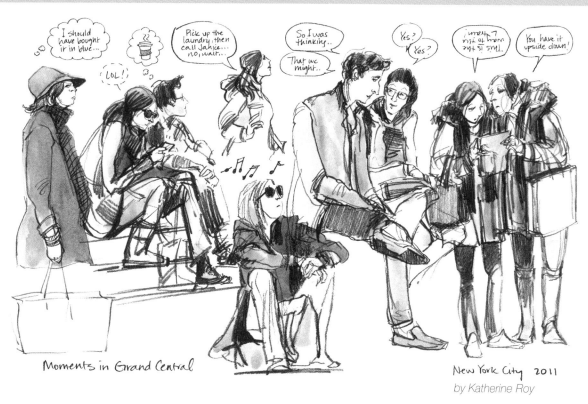

Moments in Grand Central

New York City 2011
by Katherine Roy

1. Take your sketchbook to a location where you will have the opportunity to draw a lot of different people, like a public park or a busy street corner.

2. On a single page start sketching the people you see. Don't worry about where on the page you place your figures. You can draw one figure big, draw one small, or layer figures slightly if you'd like. Draw at a brisk pace, and don't overthink it. Keep drawing until you have at least four figures.

3. Look at your page. How could you turn these sketches into a story? Use word balloons and captions to add a narrative layer to this image.

Katherine's Figure Drawing Tips

- Figure drawing on location is about catching movement. It's about learning to 'read' real people by watching the way they occupy space. How do real people stand? Flirt? Eat? Walk?

- Spend more time looking at the figure than at your drawing. Move fast, keep going, and don't worry about making it pretty! If and when your subject moves or walks away, simply look for another figure in a similar pose—a drawing can be completed using multiple people!

- Drawing the figure in motion is a tough challenge—sometimes you only have a few seconds!—but these studies are visual research that give you character clues for making comics.

Copycat

Materials

- comics section of a newspaper
- tracing paper
- paper
- pencil
- pens

"Good artists borrow, great artists steal."

—Pablo Picasso

As a cartoonist, your goal should be to create your own characters, worlds, and stories. But you can also learn a lot from copying others. Trying on different drawing styles is a great way to improve your skills.

R. Sikoryak has made a name for himself by aping other cartoonists. His comic parodies combine serious works of literature with "lowbrow" comic art. At right is a mash-up of Dostoyevsky's *Crime and Punishment* and Bob Kane–era Batman.

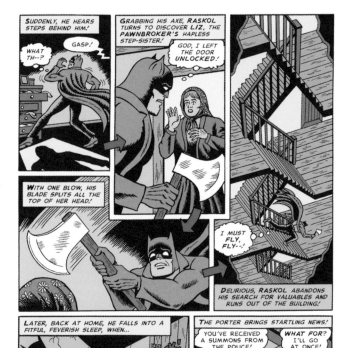

by R. Sikoryak

Let's Go!

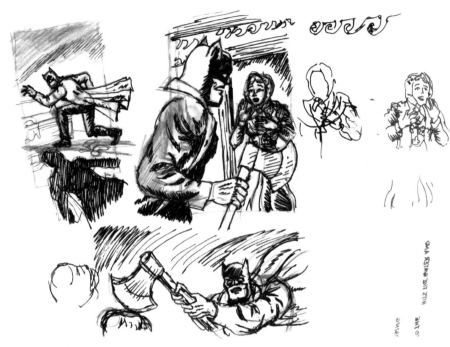

It takes R. Sikoryak a lot of painstaking research and preparation to create a spot-on parody.

1. Open your newspaper to the comics section. Alternatively, you can use a comic strip encyclopedia (*100 Years of Comic Strips* is a great example).

2. Pick two comic strips. One should be a strip you really like, the other should be chosen randomly.

3. Use tracing paper to trace the comic strip you really like. This is only a practice step—once you're warmed up, put your tracing paper aside.

4. Without thinking about it too much, sketch a comic strip in the style of your chosen strip. Make the strip your own by changing names, locations, or situations.

5. Repeat these steps for your second comic strip choice.

R. Sikoryak's Tips for Parodies

"To match the visual and storytelling style of a specific comic, I go through a number of steps. First, I gather many samples of the strip I'm parodying, which I study carefully. I'll make scans or photocopies of particular panels and sequences that I may want to use as reference for figures or layouts. I then create a file of reference that I can look at while I'm drawing my version of their strip. Sometimes I'll try to find interviews with the artists and learn what tools they use (specific papers, brushes, pens, or computer techniques) and the size at which they work. It can make it easier if you use the same techniques that they do.

"The drawing is a process of trying to 'forge' the compositions and line quality of the original artist and eliminate all traces of my personal style. It can take several drafts to really get it right! I often work on tracing paper so I can revise and retrace my drawings onto a new page, before I light box the best ones onto the final bristol board. The samples shown here from *Dostoyevsky Comics* are just a small portion of the many sketches I drew before I penciled and inked the final page. If you like the person whose work you're parodying, it can be a very fun way of learning from them."

LAB 8 The One-Panel Gag

Materials

- scrap paper
- kitchen timer
- pencil
- eraser
- bristol board

"Everything in a gag cartoon should serve the joke or make it funnier. Perhaps something in the background can help the joke ... something as tiny as a raised eyebrow that elevates a chuckle to a full-on guffaw."

—Karen Sneider

In the next unit we will explore how to place images within a sequence, and how to structure that sequence. Before we move on, though, let's look at a form of cartooning that tells a story in one image: the one-panel gag comic. The one-panel gag is a very old form of cartooning, and variations on this form were the earliest type of cartoon to appear in newspapers. You might have noticed I call them cartoons, and not comics. People quibble over semantics—what's a cartoon, what's a comic, what's a graphic novel? Although it's hard to agree on common definitions, there is general agreement that the one-panel gag is different from the multipanel comic book. The basic nature of the comic book, the thing that makes it tick, is tied up with sequence. Put simply, one-panel gags are close relatives to the comic book (first cousins, at least), but they have their own structure and logic.

Karen Sneider is a comedienne and a *New Yorker* cartoonist. Getting accepted by the *New Yorker* is no easy task. Karen needs to make a lot of notes and sketches before a cartoon is accepted. Below she shares a little of her process.

Let's Go!

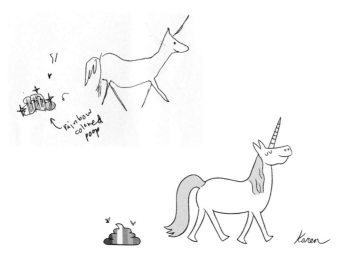

by Karen Sneider; originally appeared in Nickolodeon Magazine

1. Grab some scrap paper (take some from the recycling bin if you have one on hand). At the top of one sheet of paper write "Desert Island."

2. Set your kitchen timer for 20 minutes.

3. Start writing down words you associate with a desert island. Let one word suggest another, and don't worry if your idea gets away from you. Don't try to judge your ideas as "good" or "bad;" just write what comes to you.

4. After writing for 7 minutes, look at your word list and start sketching. Sketch loosely and quickly, and try to draw as many items on your list as possible. Combine ideas or move in different directions—the important thing is to keep your pencil moving.

5. Stop sketching once your kitchen timer goes off. Look at your pile of doodles. Which is the funniest?

6. Take your best doodle and redraw it in pencil on bristol board. Keep your drawing as simple as possible. A cartoon is like a haiku: challenge yourself to get the idea across with as few lines as possible.

Karen's Tips for Writing Jokes

"When I'm trying to think up jokes, it's very rare that a hilarious idea will suddenly pop into my head. I usually have to sit down and make myself think of it, whether I'm inspired or not. The first thing I do is choose a subject or an idea I want to write gag comics about. It could be anything—for example, hang gliding, smart phones, or a standard gag subject, the psychiatrist's office. I then take 20 minutes and try to write as many jokes as I can about it. I actually use a kitchen egg timer to time myself. This time limit of 20 minutes per subject keeps me from getting bored or wasting time on an idea that's going nowhere. On a piece of scrap paper I'll write down words I associate with a psychiatrist's office, like 'couch, therapist for dogs, therapist is a dog, no dogs on the couch,' or whatever comes to mind. I then start doodling the images those words evoke, such as pictures of a person on a psychiatrist's couch, the diplomas on the wall, a therapist handing a crocodile a box of tissues, and what have you. And then, for whatever reason, once my pen is moving and ideas are flowing, jokes naturally begin to arrive.

"Whenever I think of a joke, I grab a new piece of scrap paper and draw a very rough drawing of it in a loose, sloppy style using little more than stick figures. I then put it to the side, (actually, I like to throw it on the floor, but feel free not to be a complete slob like me) and then move on to the next paper and try to repeat the process.

"At this stage, some of my ideas are going to be completely terrible, and that's okay. I try not to get frustrated and keep going. Sometimes there's a spectacular idea lurking right behind a complete stinker. Sometimes I'll deliberately draw the dumbest, most ridiculous things I can think of because sometimes they'll lead to a much better idea right after or when I look at them later.

"When I'm done drawing, I collect what I think are my best jokes and show them to someone whose opinion I trust. I listen to his or her response and judge accordingly. This is actually my favorite part because I love making people laugh, and cartoonists can't really look over the shoulder of someone who's reading it in a magazine."

Page Building

PAGE DESIGN—SOUNDS BORING, RIGHT? You're probably ready to start drawing comics already. But a basic understanding of the page is necessary if you want to make comics that work. The art of page building—how you place a panel within a tier, a tier within a page, and a page within a spread—is an essential part of cartooning. Through careful design you can set the tempo of your page and make certain moments magic. So dive right into Unit 2—page design isn't as boring as you might think.

UNIT

2

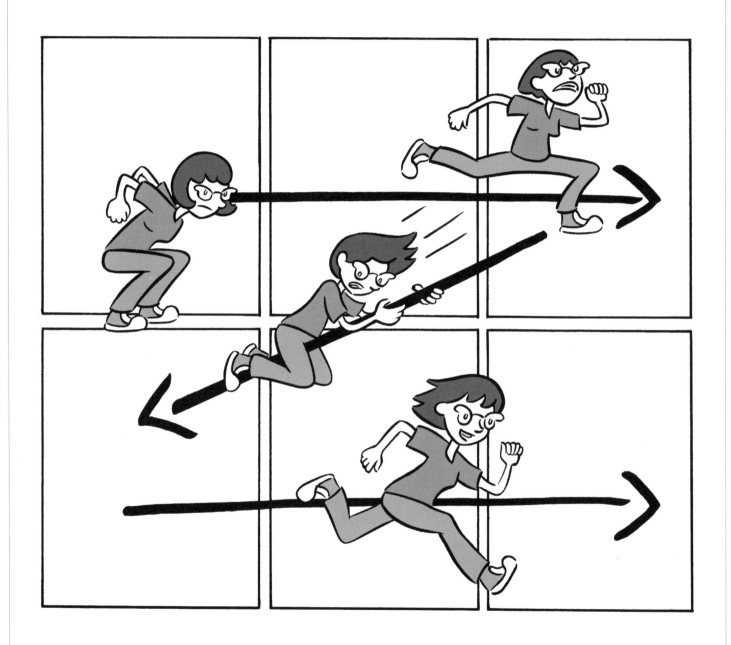

Page-Building Basics

- kitchen timer
- paper
- pencil or pen

Tip

The rule of directional flow is not to be broken lightly. It can be jarring to read prose in one direction and images in another.

The comic book page is made up of a sequence of images. Each of these images is usually (though not always) contained within a rectangular border. This rectangular border, and the image within it, is what we call the panel. It is the most basic element of the comics page.

Panels are arranged into horizontal rows called tiers. Tiers have their own unique function on the comics page, which we will discuss in detail in Lab 15.

There are a few hard-and-fast rules to building a page of comics, and a lot of general guidelines—though both rules and guidelines are meant to be broken when there's due cause.

The rule of directional flow is one of those hard-and-fast rules. In most Western cultures we read comics the same way we read prose: left to right, top to bottom. If you're a fan of manga, or Japanese comics, you know that their comics (like their prose) read from right to left. Directional flow is not a rule you can break lightly. It can be jarring to read prose in one direction and images in another, and going against the grain may confuse your reader. So, for the purposes of this book, it's recommended that you go with the flow: left to right, top to bottom.

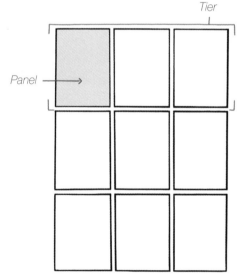

Most comic book pages are made up of panels and tiers.

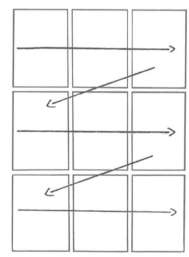

The rule of directional flow: left to right, top to bottom

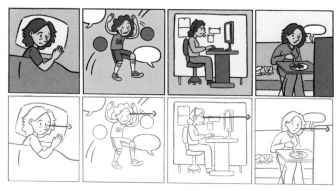

You should also maintain a left-to-right flow within your panels.

Not only should your panels be placed in a left-to-right sequence, but you must also maintain this flow *within* your panel borders. Your images themselves should reinforce the left-to-right movement. For example, if you draw a character walking, it's a good idea to have him walking to the right, not the left. Even still objects such as a face, a hand, or your character's eyes can benefit the reading flow if they're drawn pointing to the right.

Word balloons also need to be positioned in a left-to-right sequence (more on lettering in Lab 34).

Of course, there are appropriate moments to break the left-to-right rule—perhaps you want to interrupt the reading flow slightly or maybe you want to suggest the idea of going backward.

There are a lot of things to keep in mind when you're building a page of comics. How do you keep them all straight? You need a good blueprint before you start drawing, and we call those blueprints thumbnails. Thumbnails are simple preliminary sketches of your pages. They allow you to work out your page design before you do any painstaking drawings. Thumbnails aren't meant be pretty—this process is all about visualizing information, not making art. Simple drawings or stick figures will do the trick.

Let's Go!

1. You are going to thumbnail a two-page retelling of a story we all know: Little Red Riding Hood. Feel free to interpret or abbreviate the story as you'd like. Set your timer for 2 minutes. Spend that time thinking about how you can fit the story into two pages. Feel free to take notes, but don't start drawing yet.

2. After your 2 minutes are up, take a piece of letter-size copy paper and fold it in half. Each half will be a page of thumbnails.

3. Set your timer for 10 minutes and start drawing. If after 5 minutes you haven't completed one page of thumbnails, you're probably making your drawings too elaborate.

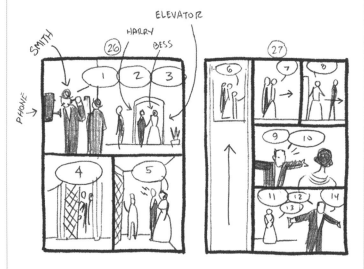

These thumbnails were drawn by Jason Lutes for the graphic novel Houdini: The Handcuff King. *Jason handed off the thumbnails and a detailed script to Nick Bertozzi, who illustrated the book. In collaborative projects a lot can get lost in translation, but clear thumbnails go a long way toward visualizing the comic book that's inside your head.*

Page Size and Reduction

- T-square
- bristol board
- pen
- clear ruler
- proportion wheel (optional)

"Try to think of the comics page as a chunk of creative real estate. Everything from the panel borders to the gutters to the lettering style is fallow ground that can be cultivated for greater impact."

—Jon Chad

Traditionally, comic book pages measure 6⅔ × 10¼ inches (17 × 26 cm). If those numbers are hard to memorize, just remember 6 × 9 inches (15 × 23 cm). Comic art generally measures about that size on the printed page, though it's drawn a lot bigger than that. Why draw big? It's easier to create detailed work at a larger size, and your inking will look tighter once it's reduced.

Many professionals draw comics at 10 × 15 inches (25.4 × 38 cm), which is a larger ratio of 6 × 9 inches (15 × 23 cm). You can even buy pre-ruled bristol board pages at this size. You might find this size is too large for you, or maybe you want a comic page whose proportions won't fit in a 6 × 9-inch (15 × 23 cm) ratio. How do you pick the perfect size for your art?

Before you start drawing your comic page, ask yourself these questions:

What size will your printed comic book be?

If you're self-publishing, then you're likely using a photocopy machine with letter-, legal-, or tabloid-size paper (we'll go over this in detail in Lab 43). If you're having your book professionally printed, then your print shop can suggest several standard page sizes. It's a good idea to determine the size of your printed page before you start drawing.

How will you transfer your comic art to the printed page?

Most likely you will use either a scanner or a photocopier for this step, with a scanner offering more professional results. Most scanners have a maximum scan size of 8½ × 11 inches (21.6 × 28 cm). If you're working at larger size, you'll have to scan your page in sections. If you draw large, you may want to invest in an oversize scanner.

Most photocopiers can accommodate a maximum size of 11 × 17 inches (28 × 43 cm), though few can match the image quality of a scanner.

Let's Go!

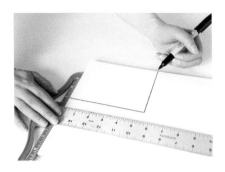

1. Once you've determined the size of your printed page, rule out a box that exact size in the lower left-hand corner of a bristol page (this step will be easier if you use the bristol while it's still in the pad). Draw your box right on the edge of the bristol, so there are no margins on the left and lower sides (the left and bottom sides of your box are actually the sides of the paper). Use a T-square so the sides of your box are parallel and your corners are at a 90-degree angle.

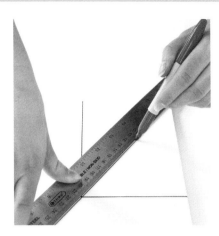

2. Grab a transparent ruler or any other straightedge (your T-square will work here, too). Line up your ruler so it bisects both the lower left and the upper right corner of your box. Make a diagonal line between these points that extends to the edge of your paper.

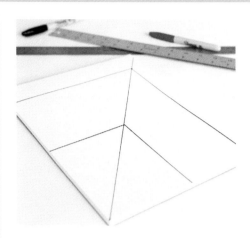

3. Mark any point on that diagonal line. Using your T-square, make a horizontal line that intersects that point, and a vertical line that intersects it. You have now made a new box that is the same ratio as your first.

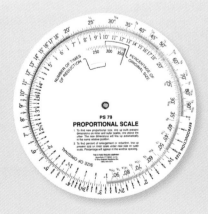

Tips of the Trade

A tool that is handy when determining reduction or enlargement, especially when using a photocopy machine, is the **proportion wheel**. Measure either the height or the width, whichever is the longest dimension, of your original art. Then take the same measurement of the printed page. On the inner wheel look for the number that matches the measurement of your original art. Turn the inner wheel until that number matches the measurement of your printed page on the outer wheel. In the window, you will see an arrow pointing to the percentage of reduction or enlargement.

Stick Figure Strips

- paper
- T-square
- pencil
- pen

It's easy to be enamored with drawing facility, but comic books are more than a sequence of pretty pictures. In comics, clarity is more important than draftsmanship. If your drawings have clarity, if the information they contain is clearly readable, then simple drawings will do the trick.

Cartoonist Matt Feazell studied art in college and is able to pull off a commercial style, but he found more satisfaction in drawing stick figures. He has been drawing stick figure comic strips starring Cynical Man and his friends for more than thirty years now!

Tips of the Trade

Comic strips are often drawn 13 inches (33 cm) wide and divided into three panels, making each of them 4⅓ inches (11 cm). But how do you measure a ⅓ inch (0.85 cm) when rulers are only marked with ¼ inch (6 mm), ⅛ inch (3 mm), and ¹⁄₁₆ inch (1.5 mm)? If you have a ruler marked with centimeters as well as inches, this is easy: ⅓ inch equals 0.85 cm. A centimeter is divided into 10 millimeters, so that's halfway between 8 mm and 9 mm. If you don't need to be exact, ⅓ inch is a little under the ⅜-inch (1 cm) mark on your ruler.

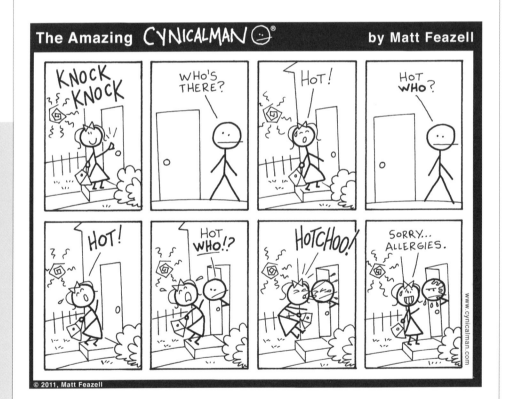

Let's Go!

The following exercise will prompt you to create a comic strip, like the comic strips you can find in your newspaper or online. Comic strips are different from comic books. The comic strip is an abbreviated and self-contained form. A story or joke must have a beginning, a middle, and an end in just two to four panels. By contrast, a comic book or graphic novel can stretch a story over any number of pages.

Most comic strips are drawn at about 4 × 13 inches (10 × 33 cm) and then shrunk for print. If you want to draw your strip at a larger or smaller size you can use Lab 10 (page 40) to find the proper ratio. You can also make a photocopy of the comic strip template below and enlarge it to a comfortable drawing size. Use a light box to transfer the template to your paper. Trace the dotted lines if you want to divide your strip into thirds or fourths.

1. You will draw a comic strip with a beginning, a middle, and an end—all in stick figures. In the first panel or two, set the stage: establish the setting, the characters, and the scenario. For example: a little girl is selling lemonade on a nice summer day.

2. In the middle panel add the "and then..." moment. Introduce something new to the strip that disrupts the balance in the previous panel(s). It could be something intangible, like a piece of dialogue or a sudden realization, or it could be something physical, like a character or an object. For example, a vampire suddenly appears at the lemonade stand.

3. In the final panel draw a reaction to the "and then..." moment. To give your strip a punch line, make that reaction counter to what we'd logically expect. Now, if our vampire had just said something we'd expect, such as, "I want to suck your blood," the reader would feel a little cheated by this ending. Playing with the reader's expectation is a big part of humor.

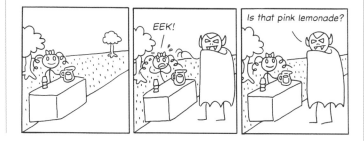

Repetition, Repetition, Repetition

- T-square
- paper
- pencil
- photocopy machine
- scissors
- glue stick
- pen

The shape, size, and number of panels on your page will change the character of your story. In this unit we'll look at many different ways to arrange your panels. But to start, let's use a simple page composition: a nine-panel grid. This kind of layout is what Ivan Brunetti calls the Democratic Grid—each panel is the same size, therefore they each have equal weight and presence on the page. Despite its rigid structure, the nine-panel grid is a fairly common page layout and it has been the foundation of many remarkable comics (Jaime Hernandez's *Flies on the Ceiling* and Alan Moore and Dave Gibbons's *Watchmen* are prime examples).

"A cartoonist is someone who does the same thing every day without repeating himself."

—Charles Schulz

Tips of the Trade

It's easy to smear your ink when you're ruling out the panel border, especially if you're using a nib or technical pen. Keeping your ruler edge elevated off the paper helps; your ink won't bleed under the edge or smear when you move the ruler. You can purchase rulers with an inking edge or you can easily modify an ordinary ruler. Just tape a few pennies, evenly spaced, underneath your ruler.

Let's Go!

1. Using your T-square, make a grid of nine panels. Make your grid three tiers tall and your tiers three panels wide. Make all your panels the same size.

2. Measure one of your panels. On another piece of paper, draw a panel that exact size. In that panel draw an "in-between" moment—a low-action moment with no dialogue that can serve as a bridge between actions. For example: our character sits by the phone, waiting for a call.

3. Use a photocopy machine to make three copies of your blank grid.

4. Next, make at least nine copies of the panel you drew.

5. On one of your blank grids, cut and paste at least two panels somewhere in the grid. You can place them wherever you please, but consider options A, B, or C as shown below.

6. Fill in the blanks to build a story around your repeating panels.

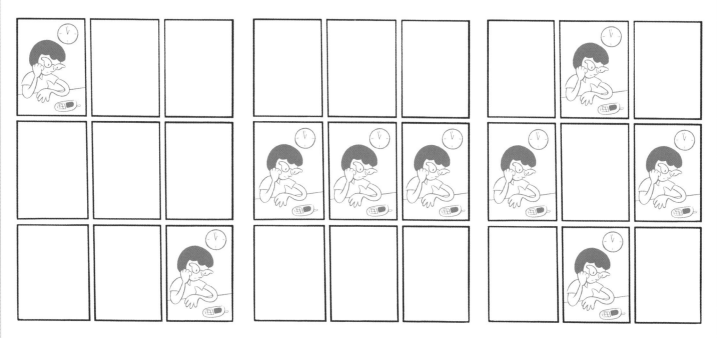

A. You can bring a story full circle by starting as you began.

B. A series of identical panels can stretch out a moment.

C. In a composition like this you can create two parallel sequences. The second sequence could occur in the past, or at the same time but in a different location. Or it could occur within the character's head.

LAB 13 Calling the Shots

Materials

- T-square
- paper
- pencil
- bristol board

"A continual closed-up picture space is likely to cause a claustrophobic feeling, which on the other hand might be the very effect you're looking for."

—Eddie Campbell

When discussing comics, we tend to borrow a lot of ideas from filmmakers. Film and comics share two important characteristics: they are story based and visual. But they also have many differences, a key one being that films are watched and comics are read.

The film concept I borrow most often, as a graphic novel editor, is the camera shot. Having a name for a certain shot is particularly useful if you're writing a comic script and need to describe a panel in words alone.

A. *The* **close-up** *focuses on the character's head, usually from the shoulder or neck up. This shot is good for intimate moments when the character's feelings are most important.*

B. *The* **medium shot** *shows the figure from about the waist up. It allows you to see more of the character's body language and is good for conversational moments.*

C. *The* **long shot** *shows the complete figure. This shot grounds the character in her setting and is good for action moments.*

D. *The* **establishing shot** *is a type of long shot that establishes the setting and the character's place in it. These panels often have a panoramic composition and signal a scene change in a story.*

Let's Go!

Grab a piece of paper and rule out a page composition with at least six panels. Thumbnail a comic about a daily activity (getting ready for work, washing the dishes, walking the dog). Your page should follow these guidelines:

1. Start with an establishing shot.

2. Draw a medium shot somewhere in the middle.

3. End your comic with a close-up.

4. Follow the feet rule as described in the sidebar to the right.

An excerpt from Eddie Campbell's King Bacchus. *Eddie Campbell is a master cartoonist who has developed many theories and rules about comics. One of his best-known rules is the feet rule, which forces cartoonists to draw a complete figure, with feet showing, at least once on the page. You can see that Eddie followed the feet rule in panel two.*

Eddie's Feet Rule

"I had agreed to do a lecture in the art department of the local tech college. This was in the 1990s when things were hectic for me, so the night before my appearance I realized I didn't have a subject. I desperately rounded up all these different theories of mine. Things like:

- We talk about 'timing' in comics, but really, a comic book arrives all at once. If Magneto is suddenly revealed to be the villain on the very last page, I've never met a kid who doesn't know this before he gets the comic book out of the shop.

- The comic page is a map of the world. Certain events are more likely to happen in certain regions, such as the center, or the margins, or south of the border.

"I had nine of these, all very complicated and demanding elucidation and discussion. I called the whole lecture Toward a Rhetoric of Comics. I trudged through it all and was greeted by blank faces. I realized I needed to pull something out of thin air, so at the end I said, 'And the final rule is, make sure you draw a pair of feet on every page.' It got the required laugh and I left with my dignity. Later I'd meet people and they'd say things like, 'That rule of yours about the feet was the only one that was any damn use.'

"So what's useful about it? First, it reminds you to avoid a series of talking heads, a tendency that often leads to tedium. It reminds you to show the whole scene before going to close-ups and fragmentary pieces. The reader needs that whole scene to glance at to clarify who is on which side of the room or whatever the location is, and how the various parties are relating to each other spatially. You also need to come back to it if your scene goes on for more than one page. And last, pulling back opens up some breathing space. A continual closed-up picture can cause a claustrophobic feeling, which on the other hand might be the very effect you're looking for, in which case, break the rule."

Panels and Pacing

Materials

- paper
- pencil or pen
- T-square

Each of these panels are the exact same size, making for a succinct and evenly paced tempo. If we play with the size and composition of our panels, we can stretch or shrink time to fit the story we're trying to tell.

> *"In comics you see the drawing, you see words, you see rhythm, you see the story. It's a space where you can do any kind of work if you conceive it that way."*
> —Lorenzo Mattotti

Let's Go!

Create a comics page with five panels or more, with these constraints:

1. At least three panels should contain short moments.

2. One panel should contain a long moment.

3. Make one of the panels silent.

One way to create a longer pause in the reading experience is to draw certain panels bigger. A big panel tells the reader, "Look at this, this is important." It's not uncommon to create a panel that takes up a whole tier, or even a whole page (the latter is sometimes called a splash panel).

Repeating a panel will stretch a moment out. In some cases, this means copying and then pasting an identical panel onto your page (this works best when there is absolutely no change or movement in the panel). In other cases, you will have to redraw the panel, keeping the basic design but adding some small changes. This sort of panel repetition gives the comic a slow-motion effect.

You can even draw a panel so large that it's not contained within its border. An image that extends to the edge of a page is called a bleed. Bleeds are particularly useful when you want the reader to examine the environment you've drawn. Your world feels more open when it extends to the very edge of the paper.

Another way to make the reader linger on a panel is to make that panel silent. Text automatically imposes a certain reading pace on a panel (we read the text, we move on). A silent panel has a timeless quality that invites the reader to drink it in.

The Tier

- index cards
- pencil or pen
- T-square
- paper

"The democratic grid need not be uninteresting or undistinguished; with a spirited approach, it can be the apotheosis of elegance, simplicity, and sophistication."

—Ivan Brunetti

The panel is the most basic element on the comic page. Panels are a bit like sentences: they're small, self-contained units that are part of a greater whole. If a panel is like a sentence, then the tier is like a paragraph. Paragraphs are unified by a certain idea; when a new idea comes along, we start a new paragraph. The same can be said of the tier. A new tier is a great place to insert change: a change in time, a change in place, or a change in character. When the reader comes to a new tier, she anticipates change.

That's not to say that every tier break, or the point where one tier ends and another starts, must usher in something new. But keep in mind that a new tier is an ideal location for a change in the story. For example, the tier break below signifies a change in time; a place visited as a child is revisited as an adult.

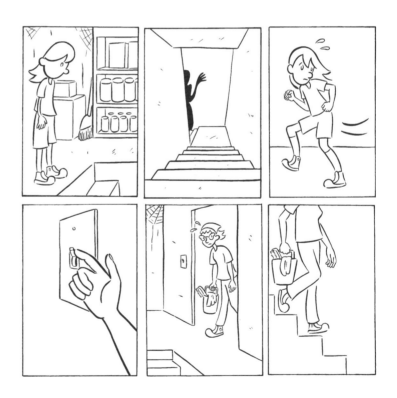

Let's Go!

1. Take ten index cards. Write a common life-changing event on each card (first kiss, the birth of a child, a trip to the emergency room, etc.).
2. Rule out a twelve-panel grid (four tiers, three panels each) on paper.
3. Randomly choose one of your cards.
4. Quickly sketch that moment in one of the last panels of your four tiers.
5. Work backward from that moment and fill in the two previous panels in that tier.
6. Repeat steps 3 through 5 until all of your panels are filled. This will create four separate sequences, each unified by their tiers and connected by tier breaks.

Tips of the Trade

American comics often have a three-tier composition. A four-tier composition is more common among the comics, or *bandes dessinées*, of France and Belgium.

A common three-tier composition

A common four-tier composition

Cartoonists without Borders

Materials

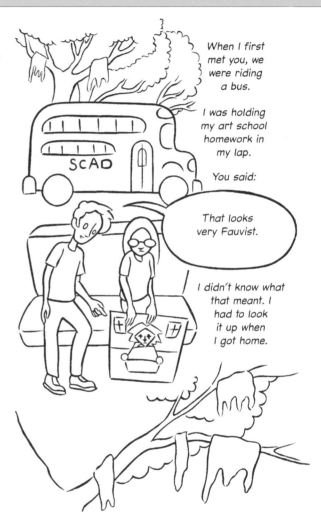

- paper
- pencil or pen

"Never put in a single line that isn't necessary ... If you have to stop and figure out a picture for about three minutes, then you've lost the thread of the story."

—C. C. Beck

Up to this point we've been using a lot of grids (nine-panel grids being a favorite of mine). A grid may offer the sort of structure you're looking for as a storyteller. It's a very accessible format—nearly any reader, even those new to comics, can digest and understand it. It also gives your comics a steady tempo (which is the right choice for some comics, but certainly not all).

The grid has its strengths, but you can tell clear and effective stories without it— and without panel borders, even!

I drew this comic without panel borders. Since I placed the text and images in a left to right, top to bottom composition, there is no confusion about reading order.

Let's Go!

1. Recall an ordinary exchange from your day: a conversation with a friend, a co-worker, or a family member.

2. Edit down a portion of that conversation to three to six panels.

3. Draw a one-page comic without panel borders. Draw your panels in a layered manner, so they are not distributed in a rigid grid design. Be sure to follow the rule of directional flow—left to right, top to bottom.

4. Show your comics to some friends. Are they able to read it without getting confused?

Tips of the Trade

You might think that without a grid or panel borders that a page of comics becomes an unreadable mess. But if you follow the rule of directional flow, your reader will know exactly where to look.

Vanessa's Davis's diary comics are often sketched in a layered fashion, without panel borders. Because the panels are arranged from left to right, top to bottom, the comics are very readable. The reader's eye will naturally follow a trail of repeated images and design elements. This repetition of faces and word balloons shows your reader the way to go.

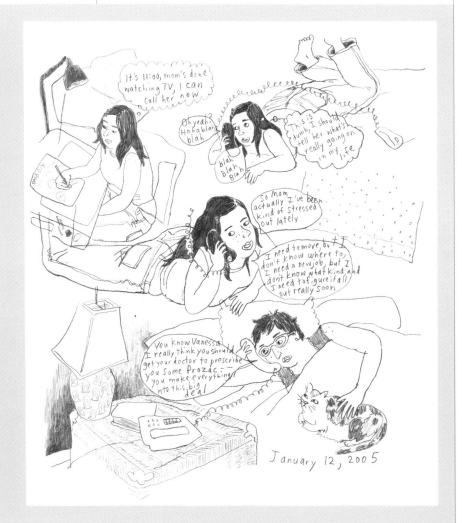

Turn the Page

Materials

• letter-size copy paper
• pencil
• eraser

"I really need to be thinking more about spreads, not pages. The spread is the 'basic unit' of comics."

—Ben Towle

Up to this point, most of these exercises have considered the page as an independent unit. But this isn't how we read comics—not in the world of print, anyway. When bound into a book, a page is read as part of a two-page spread. It matters whether a page falls on the left-hand side (verso) or the right-hand side (recto). A verso page is read after one turns a page, and a recto page is read before. The act of turning a page plays an important part in pacing your comics.

The point at which we physically turn the page of a comic book is called, not surprisingly, a page turn. Placing a cliff-hanger moment at a page turn can enhance the drama of your story. The anticipation of the unknown and the physical action of turning the page can deliver a powerful payoff. Placing the "reveal" in the middle of your page may ruin the surprise.

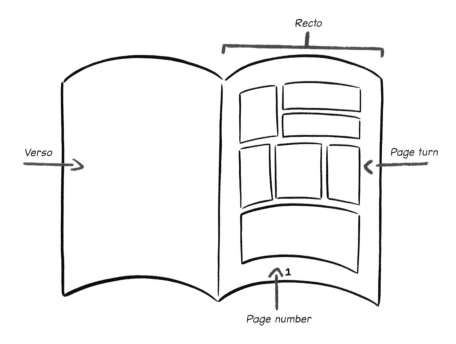

A book, comic or otherwise, usually starts on a recto page. The recto pages are given odd page numbers, while the verso page has even.

Let's Go!

1. Fold a sheet of paper in half.

2. Choose one of the comics you've made in the previous labs. Reenvision it as a four-page sequence. You can stretch out time, or change and extend the original story.

3. Thumbnail two spreads, using the front and back of your paper. Make use of the page turn.

Tips of the Trade

When you thumbnail a comic—a long comic in particular—you'll need to create a system for recording where the page turns fall. Jason Lutes (see Lab 9) draws very small thumbnails in his sketchbook and underlines the page turns. James Sturm (see Lab 20) uses a binder with plastic sleeves, so he can easily see how the two-page spread will look and where the page turns will fall. Below, I adopted his method for a graphic novel project of my own.

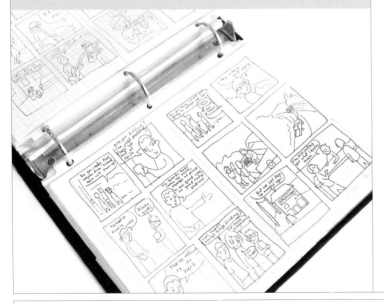

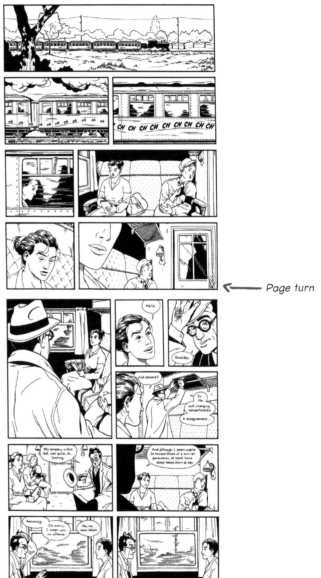

Page turn

A page turn from the first two pages of Berlin, *by Jason Lutes. In this sequence, Jason does something very clever; the act of turning the page mimics the act of his character opening a door.*

Storytelling

SO YOU HAVE THE BASICS OF PAGE BUILDING DOWN,
and now it's time to draw some stories. But where to start? My best advice: start small. Put that comics opus you've been dreaming about since you were thirteen on hold for a while. Any runner will tell you that starting a marathon without proper training is a recipe for disaster (many suggest a full year of training before your first race). Consider these labs as your training regime.

The following exercises are designed to jump-start your stories. A few of them have you starting from scratch, with little more than a memory, an image, or a bit of text to work from. And they don't require prior planning—in fact, planning would work against you. Instead, they call on your imagination, life experience, and ability to improvise to allow your story to grow organically. Don't overthink these exercises, and don't worry too much about whether your comics are "good." Treat these exercises as a form of play, and you'll create stories that will surprise you, ones you never thought you had in you.

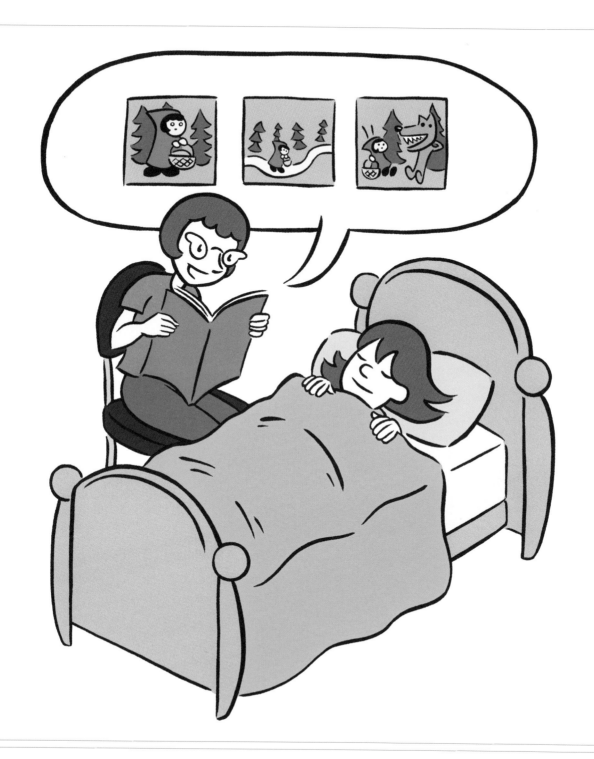

18 Drawing without Stopping

Materials

- notebook paper
- kitchen timer
- pencil
- ruler
- pen
- bristol board

"Is this good? Does this suck? I'm not sure when these two questions became the only two questions I had about my work...I just know I'd stopped enjoying it and instead began to dread it."

—Lynda Barry

I don't know about you, but my worst critic has always been me. The desire to make "good" art can motivate, but there is a flip side—the fear of making "bad" art can immobilize, leaving you too afraid to make art at all.

There's another way to think about art making, one free of judgment, thinking, or planning. This is a playful sort of art making that's closer to the way children draw. You probably drew this way when you were younger—nearly everyone did. It was just for fun, without thinking about the final outcome. As we grow older, it's harder to hold on to this playfulness.

The following exercise was inspired by the teachings of Lynda Barry (who was inspired by the teachings of Marilyn Frasca). Lynda's book *What It Is* perfectly captures this struggle of making "good" art and offers several exercises that prompt students to create free of judgment.

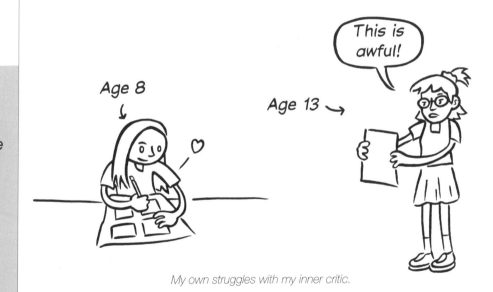

My own struggles with my inner critic.

Let's Go!

1. Pick a time of day when your mind will be fresh, your body rested, and you won't be distracted. For me, this is in the morning, before going to work.

2. Grab your notebook paper and set your timer for 5 minutes. Write "I'm afraid of..." at the top of your paper. Underneath, make a list of things that scare you. Keep writing for 5 minutes, without stopping. If you can't think of anything, write the word *fear* until you have something, or doodle little shapes in the margins. The important thing is to keep your pencil moving.

3. Look at your list. Did anything surprise you? Pick a fear that you would feel comfortable exploring in words and pictures.

4. Create a nine-panel grid.

5. In your first panel, draw a moment when you might begin to feel the fear you picked. Start by drawing yourself, then fill in the blanks around you. Draw without stopping—always keep your pencil moving. Keep your drawings loose and sketchy. Don't erase. If you can't think of anything to draw next, trace some lines you've already made.

6. After that first panel, your story can move in any direction: reality, fantasy, or something in between. Keep drawing without stopping until you've filled your nine panels. Don't plan or think ahead, except for this: as you reach your ninth panel, try to give your page an ending that feels complete.

7. Put your comic away for a week, and don't look at it or read it. After a week, take a look. What do you think of the story you made?

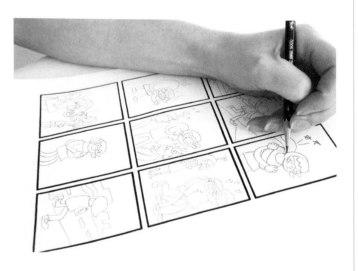

LAB 19 Show OR Tell

- notebook paper
- pencil
- kitchen timer
- pen
- bristol board

Contrary to what most people think, when we talk about writing comics, we're not just talking about all the letters that go in the word balloons. Cartoonists write with both words and pictures and each are capable of delivering information. In the best comics, words and pictures complement each other, creating a story that's greater than the sum of its parts. You want to avoid redundancy in your words and pictures; it makes for a stilted and boring type of storytelling. A good rule of thumb is show OR tell, but don't show AND tell. Like every rule, the rule of show or tell is meant to be broken, when there's good reason—some stories evoke a certain tone that is enhanced by redundancy.

How can you tell whether your words and pictures are redundant? Try reading the comic two ways—once with your hand covering the text, and again with your hand covering the pictures. Do you get the same story either way? For more on redundancy, or "duo-specific word/picture combinations," as Scott McCloud calls them, I recommend reading chapter 3 of Scott's book *Making Comics*.

Tip

Try reading the comic two ways—once with your hand covering the text, and again with your hand covering the pictures. Do you get the same story either way?

These captions have been altered to deliver redundant information. Would you want to read the rest of this story?

If the narration of my short comic *Never Go Home* were removed from the images, it would look something like this.

When I ran away, I never had a plan. I just wanted to get out and get away.

Get away and never come back. I thought this was possible.

Of course, it wasn't.

By itself, this suggests a story, but not the whole story. We have just a hint of who the character is and no sense of place.

If we look at the pictures only, we are able to see the character, his actions, and his place in the world. Through facial expressions we get some sense of his state of mind, but without the text we don't know why he is walking alone, in the middle of the night. When the images and the words are brought together, we get the whole story.

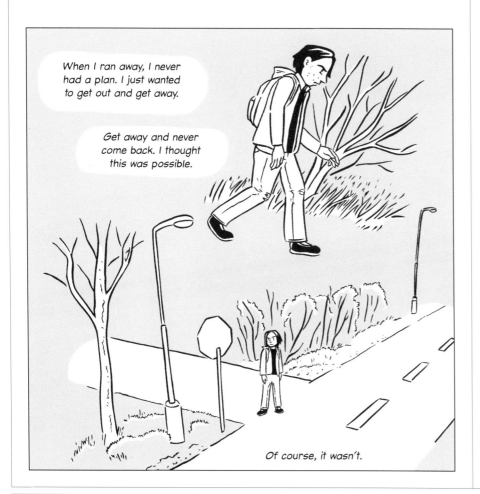

Let's Go!

1. Grab your notebook paper. Make a list numbered one through five.

2. Drawing from your own experience, list five memories you associate with the word *lost*. Briefly summarize these memories in one sentence each. It could be a time when you were lost, felt lost, or watched *Lost* on TV. Any memory is fair game, as long as it has a strong sense of place. Start writing, and don't stop moving your pencil until you have your list of five memories. If you can't think of anything, keep writing the word *lost* until you think of something.

3. Select the memory that is most vivid to you. Write about that memory for 5 minutes straight, without stopping. Write in the first person, present tense (*I am walking alone in the financial district, and I can't find my train*).

4. Select four to six sentences from your writing to narrate a page of comics. Write them on your bristol board in a left to right, top to bottom manner, but don't use panels.

5. Create images to complement those words without being redundant.

Panel per Day

- 4 × 6-inch (10 × 15 cm) index cards or bristol board
- pencil, pen, watercolor, or other drawing tool
- 4 × 6-inch (10 × 15 cm) photo album

photos this page by Michael Lopez

Our next exercise comes from James Sturm, the director of the Center for Cartoon Studies. James has created several graphic novels that were carefully scripted, researched, and thumbnailed. Hard work like that pays off, but it's easy to get bogged down by such a methodical process. Creating work that's spontaneous, just for fun, might give some much-needed balance to your creative life.

"If you want to be a cartoonist, you have to do the work: you can't just talk about your characters and plot, and research endlessly. You actually have to make finished pages and finish your comics."

—James Sturm

Let's Go!

1. Grab your index cards, or cut bristol board into 4 × 6-inch (10 × 15 cm) sheets.

2. Start by filling one card with an image. Select something that has caught your interest lately, something that's been on your mind (even if you're not sure why). Don't think about it too hard. You can use pencil and ink this image, or you can use watercolor or ink wash—any medium is fair game.

3. On the following day, create another image that speaks to the one you just made. Don't try to plan out a story, and don't think a few steps ahead.

4. Continue to draw your panels, one a day, until you have filled your photo album. Move panels around or take panels out if they're not working.

James's Tips for Working More Intuitively

"When I start a graphic novel, I begin with a story and then go about constructing a narrative and filling in panels, one after another, until my story is told. This works fine, but there is a danger of this method becoming too linear and lacking a sort of poetry that can only be created when you are only half awake. Since I'm pretty deliberate in my approach, I've come up with another process that I have been doing about once a year that forces me to work more intuitively.

"I start with rendering a drawing with whatever image that leaves an impression on me, whether I saw it in a magazine, another cartoonist's comic, or a dream I had. I draw it on a 4 × 6-inch (10 × 15 cm) paper and then slide it into a blank forty-page photo album (the type you can buy at a dollar store). As I keep adding drawings, they start speaking to one another and start suggesting additional images to join them. Because the drawings are in those little plastic sleeves (and not bound in a sketchbook), I can rearrange them in the book in an attempt to create visual rhythms, which are as crucial to my graphic novels as the straight-forward 'story' I am trying to tell.

"I usually do one or two of these drawings a day and within a few months this exercise results in a 'book' that may not make a lot of narrative sense but makes me more sensitive to comics' more poetic possibilities. Plus, it gives me a chance to externalize images that I'm drawn to. These inevitably find their way into future books."

LAB 21 Jam Comics

- four or five cartoonists
- a large table and several chairs
- letter-size copy paper
- bristol board
- pencil
- eraser
- pen

"In a collaborative situation, it's nearly always better to approve, extend, or twist your fellow cartoonist's work than to negate it."

—Isaac Cates

Our next exercise comes from Isaac Cates, a comics academician who has taught about the graphic novel at Yale, Long Island University, and currently at the University of Vermont. As a cartoonist, he is drawn to collaboration and most frequently collaborates with fellow academician Mike Wenthe. Isaac has published a number of jam comics, which is something of a feat— though jamming is a fun activity, it's rare to create work that is fit for publication. On the next page, Isaac shares his jamming tips.

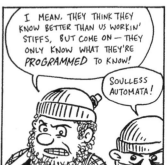

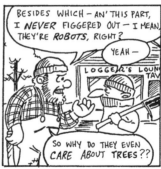

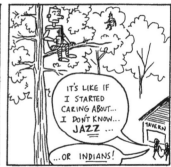

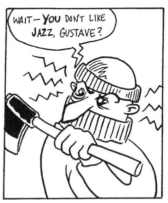

Let's Go!

1. Meet a few other cartoonists, and convince four or five of them to be in the same place at the same time.

2. Before you start drawing, everyone should jot down a few possible titles for one-page humor strips. Good titles imply a world, a problem, and an irony.

3. Each cartoonist will take one title from the pile and use it to start a one-page comic (this usually means putting the title at the top of the page). Pencil at least one panel before you pass the page to the middle of the table, and go for a while longer if you have ideas. Save the inking for later.

4. The first cartoonist to run out of steam puts his or her page in the middle of the table and starts another page with a new title.

5. If there's already a page in the middle of the table, you can swap your page-in-progress for it, but when you do, you have to add at least one panel to the story. When you start adding to someone else's beginning, try to imitate his or her drawing style; try to extend his or her ideas rather than abandoning them. "And then" is better than "Meanwhile," which is better than "Never mind."

6. As you get close to the end of the page, keep in mind that you need to set up a punch line, or at least a conclusion. Keep the beginning in mind, and the title, too. It's tricky, but remember that you're trying to draw something that holds together.

7. When a page is fully penciled, choose one person to do all the lettering and another to ink the entire page. This will help create more consistency in the final product.

Opposite Page: *A jam comic. Mike Wenthe wrote and penciled panels 1 through 3, Tom Hart wrote and penciled panel 4, and Isaac wrote and penciled panels 5 and 6. Jon Lewis inked the page.*

Right: *Excerpt of a jam comic with a title by Tom O'Donnell. Isaac wrote and penciled panel 1, Tom O'Donnell wrote and penciled panels 2 and 4, Bill Kartalopoulos wrote and penciled panel 3. Isaac did the inking.*

Isaac's Jamming Tips

"Jams often turn out to be more fun to draw than they are to read, because the hijinks and surprises of the moment often don't produce a unified whole. When my drawing group would jam, we used a small set of rules—a game, really—to make the final results hold together a little better. In the exercise, I'll explain how we played it.

"Above all, we were determined to keep the ideas of our fellow cartoonists moving forward. In a collaborative situation, it's nearly always better to approve, extend, or twist your fellow cartoonist's work than to negate it. We tried to go on with each strip's initial characters and tone as closely as we could, so that the places where we switched artists wouldn't be too visible. For that reason, in the end, one person usually did all of the lettering for an entire issue, and each page would usually have just one inker.

"The best part about collaboration is that you'll wind up drawing things that you never would have imagined on your own. Jams are never going to be personal expressions, but they can be great little stories, and a lot of fun."

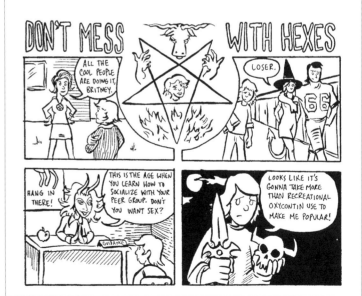

- a book of comic strips
- photocopy machine
- scissors
- glue stick
- bristol board
- pencil
- eraser
- inking tool of your choice

"Anyone who has done one of these Suspect Device jams can't help but learn something new about drawing, pacing, and design."

—Josh Bayer

The following exercise comes from Josh Bayer, a cartoonist who teaches his craft in multiple locations across New York City. It is inspired by Five Card Nancy, a card game invented by Scott McCloud. To play Five Card Nancy you don't use playing cards, you use an assortment of panels from Ernie Bushmiller's classic comic *Nancy* (the official rules for Five Card Nancy can be found at www.scottmccloud.com).

Much like Kurt Cobain, who claimed he created Nirvana's sound based on what he *thought* punk sounded like, Josh invented Suspect Device based on how he thought Five Card Nancy was played. This accidental invention led Josh to his most popular comics project.

Josh's *Nancy* Assignment

"When I was a teaching assistant to Tom Hart, he liked to give out short assignments to jump-start a student's creativity. Sometimes they involved redrawing old comics or old panels, or using old characters as a leaping-off point for new comics.

"One of the assignments that we didn't have time to get into was Scott McCloud's Five Card Nancy. Tom described it loosely: 'A student is handed some random Nancy panels, chooses two unrelated panels, and makes up a story to connect them.'

"I assumed that the game was about drawing the missing action. (I later learned it was about juxtaposing random images.) So when I began my teaching career I gave out the *Nancy* assignment, which I *thought* was Five Card Nancy.

"Anyone who has done one of these Suspect Device jams can't help but learn something new about drawing, pacing, and design. It's wonderful to pick apart the work of these older cartoonists, figuring out the habits they had ingrained after years of daily comics making (*Oh, that's how E. Bushmiller drew grass. Hey, I never noticed Nancy's legs are the same width at the ankle and thigh...*). As my friend Tom Hart said to me, 'It's one more way of discovering stories you didn't even know you had in you.'"

Let's Go!

1. Find a book of comic strips by one of the classic cartoonists. A collection of Bushmiller's *Nancy* strips is preferred, but any old comic strip will do.

2. Open a page and randomly point to a panel. This will be the beginning of your comic. Turn to another page in the book, and point to another panel. This will be the end of your comic. If you'd like, you can use a different comic strip for your last panel (Josh started with *Nancy* but ended with *Garfield*).

3. Photocopy your panels.

4. Create a story that connects your beginning and ending panels. Paste your photocopied panels onto your bristol board and draw new panels to complete the story.

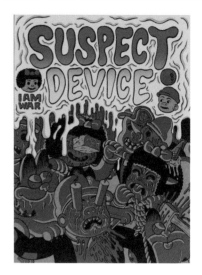

Right: *Jon Vermilyea's cover for* Suspect Device 2, *edited by Josh Bayer*
Below: *Josh Bayer's Suspect Device comic starts with* Nancy, *but ends with* Garfield.

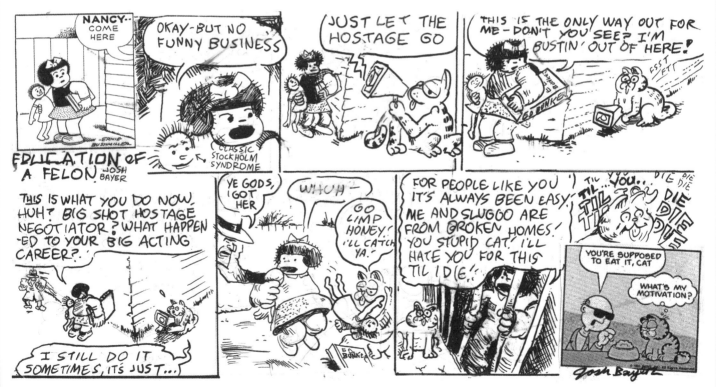

On Location Comics

This lab comes from Jessica Abel, cartoonist, educator, and coauthor (with her husband Matt Madden, see Lab 39) of the seminal text *Drawing Words & Writing Pictures*. This exercise challenges her students to draw a location from observation only, without reference photos.

- notebook
- pencil
- eraser
- pen
- sketchbook
- a location where you can draw

"Close observation of the real world can be really inspiring for inventive storytelling."

—Jessica Abel

From Sayonara *by Matt Madden*

Let's Go!

1. In a notebook, write a description of a location as seen through the eyes of someone who is about to move far away. This location should be a real place you have been to and can easily revisit. The person could be a lifelong resident or on a short tenure, but the move should be imminent. But, in the description, don't mention the fact that the character is about to move. The idea is to imbue the place with the feelings of the person moving: joy or sadness, nostalgia, or a combination of all of the above.

Make your description at least a page long, and keep the focus on description, not action.

2. Once you finish your description, visit the place, and start drawing your comic in your sketchbook. You must draw your comic on location, not by taking reference photos for later. Focus on the character's interaction with the place. While you're working, give the scene a story. Will your character, in the end, go? Will he or she achieve a sense of closure, or leave angry or sad? What are the factors that tie a person to a place? You may add characters or an interaction, but keep the actual move out of the scene, though it should be felt as a kind of resonance.

3. Draw your comic entirely in your sketchbook. Draw at least two pages; if you have a smallish sketchbook, make the comic longer—four to six pages.

From Sayonara *by Matt Madden*

Jessica's Tips for Setting the Tone and Mood

"This activity is a form of improv, but a structured one. It won't lead you to create a propulsive plot (sometimes there's none at all; sometimes there's a subtle, implied story). The main point is to come to a better understanding of how one can use drawing to set a tone or tell a story about mood. This can be done in subtle ways, like carefully choosing the subject of a given panel, or more broadly, by using tools like distorted perspective.

"A secondary mission with this activity is to get you to look carefully at a real place and to figure out ways to utilize that space for story purposes. Close observation of the real world can be really inspiring for inventive storytelling.

"As an unrelated benefit, it's also always useful to do somthing physically difficult and a little embarrassing. Standing in the street drawing comics is a great confidence-builder."

Dream Diary

- notepad
- pencil
- eraser
- bristol board
- inking tool of your choice

"The words and pictures that make up the comics language are often described as prose and illustration combined. A bad metaphor: poetry and graphic design seems more apt."

—Seth

There are different theories as to why we dream. Sigmund Freud would say our repressed shame is bubbling to the surface, Carl Jung would say we are problem solving while we sleep, Allan Hobson and Robert McCarley would say our brain is trying to make sense of randomly firing neurons. Regardless of what they mean (or don't mean), dreams provide a mixture of images, ideas, and words that our conscious minds can't manufacture. What better fodder for a comic book?

I asked two cartoonists, Jesse Reklaw and Melissa Mendes, to explain how they draw their dreams.

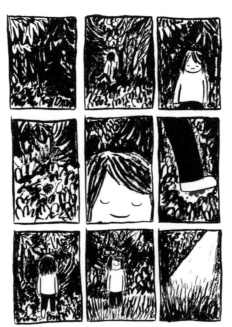
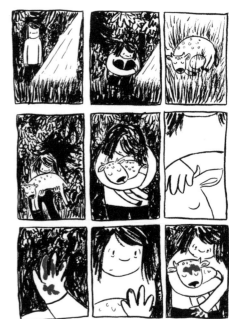

From Warmth *by Melissa Mendes*
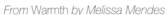

Let's Go!

1. Make a commitment to remember and record your dreams for a week. Don't be discouraged if you can't recall much after one or two nights. Your recall should improve over time.

2. Keep a notepad and pencil near your bed. Make it a notepad, rather than a notebook or sketchbook—that way, it will always be open and ready. You can also try keeping an audio recorder near your bed. Try either method—depending on your state of mind first thing in the morning, it might be easier for you to write rather than speak when you're half awake.

3. Immediately, upon waking, grab your notepad and write what you remember from your dream. Write in an abbreviated fashion, rather than in complete sentences. Your dream will fade as the minutes pass, but jotting down some key images and words will help you recall the dream later.

 Don't wait until you're fully awake to write things down. You may find it helpful to write without opening your eyes (though this makes for messy handwriting).

4. After a week, select a dream that strikes you as being uniquely charged or evocative. Draw a one- or two-page comic based on that dream. Carefully pace your comic, and consider whether the presence or absence of words would benefit the work.

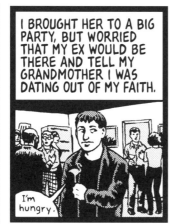

From Slow Wave *by Jesse Reklaw*

Jesse's Tips for Drawing Your Dreams

"If you're having trouble recalling dreams or if you're one of those people who just 'doesn't dream,' then I'd recommend starting a dream journal. Record what time you went to bed, if you ate or drank anything right before bed, what time you got up, and anything from your dream(s) that you remember. You might find that certain foods aid dream recall for you, or that drinking a six-pack before bed silences all dreams, or that you dream more when you sleep later. The third and longest REM sleep stage starts about 6 to 7 hours in, so if you sleep for 9 hours you'll get all that REM sleep!

"After practicing a while you will start remembering more and more. Try to journal as soon as possible after waking. Jack Kerouac refers to these nearest dream details as 'fresh from the pillow.' I always start with the very last thing I recall before waking up, then flash-back to any exciting details that stick out in my mind. Once I get a few incidents down, it's easier to sort the clues into a chronological story (or not—some people just dream nonlinearly!). But after a few months, when you find yourself spending all morning writing down dreams, maybe it's time to pick a different hobby!"

Melissa's Tips for Drawing Your Dreams

"My teacher, Jason Lutes, gave my class the assignment of remembering their dreams, without telling us exactly what we'd be doing with it. Part of the assignment was to not look at any sort of screen for at least 6 hours before we went to sleep, to help us remember our dreams better. We brought what we had written down about our dreams to class, where he had us draw an image from the dream. That became the cover, then we were left to create the rest of a comic. For me, what made this assignment successful was that the creation of the comic was almost a lucid experience in itself. I had written down some details about my dream, but instead of planning out the comic in thumbnails and pencils, I just kept the images from my dream in my head as I drew directly on the page with a brush and ink. The end result doesn't literally translate my dream into a comic, but it still feels dreamlike."

Interview Comics

Materials

- audio recorder
- sketchbook
- pencil
- eraser
- bristol board
- inking tool of your choice

"Any story told twice is fiction."
—Grace Paley

Our own experience is the first and often best source of story material, and for this reason some cartoonists choose to only work in the genre of autobiography. At some point, you'll probably want to create stories that go beyond your own realm of experience. The everyday experiences of the people around us are rich material that can inform our stories in a variety of ways.

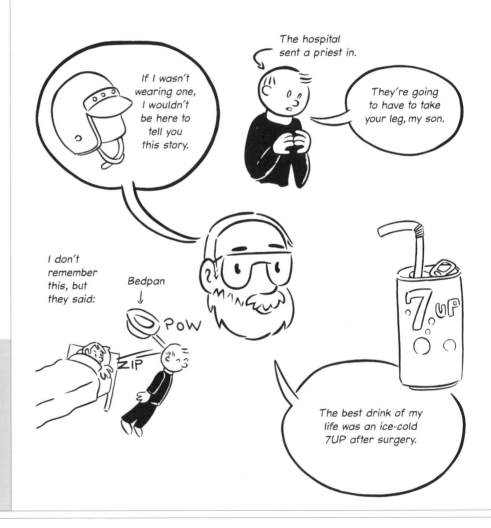

Let's Go!

If you want to accurately record and illustrate another person's story, an audio recorder is an invaluable tool. If you're looking for an approach that's more expressive and less journalistic, a sketchbook is all you need. We'll explore two approaches: one that creates a precise record and another that's akin to stream-of-conscious sketching.

1. Purchase an audio recorder, or try a cheaper option—download one of the many free voice-recording programs available for your laptop, iPod, or cell phone.

2. Find an interviewee. This may be someone close to you, like a friend or family member, or someone you know casually. In these examples I chose to interview my father.

3. Write some interview questions beforehand. If you're stumped, a question that can prompt interesting and personal stories is "When did you smoke your first cigarette?"

4. Set your recorder. Make sure it's working, then leave it alone.

5. Start sketching as you listen to the interview. If you're stumped on how to start, draw a portrait of the interviewee in the center of your page and go from there.

6. As your interviewee's story unfolds, scribble images and jot down quotations. Try to get a small part of your interviewee's story on the page and don't worry whether there are gaps in your comic—you're trying to paint a picture, not accurately record an event. Work quickly and sketch loosely; you can refine the drawing later.

7. After the interview, refine your pencils and assemble them into a one-page comic (cut and paste as needed). Ink your page.

8. Next, try a more journalistic approach. Listen to the recording you made, and select a small portion to turn into a one-page comic. Try to accurately depict your story in a linear way, being as true to the facts as possible.

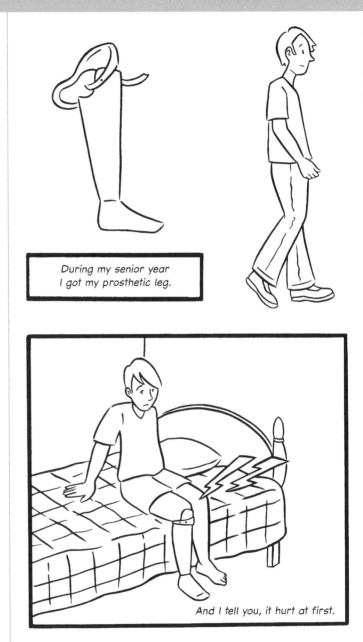

During my senior year I got my prosthetic leg.

And I tell you, it hurt at first.

26 Make a Map

Materials

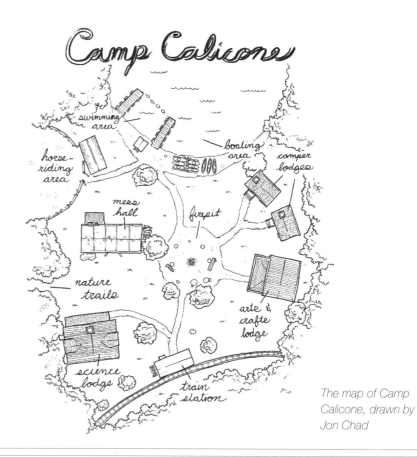

- pencil
- eraser
- bristol board
- inking tool of your choice

Tip

It might help you think of environments as three-dimensional spaces if you make a map. Think through the eyes of your characters. What do they see when they look right? What do they see when they look left? What is their neighborhood like?

For many cartoonists, the characters come first—they're the spark that ignites a story. That doesn't mean you should disregard the world that your characters inhabit, though. Cartoonists often use the word *background* to describe that world, though there is a movement to abandon that term. For some, background means backdrop, a two-dimensional surface that characters stand in front of. For cartoonists who want to create a real sense of place in their comics, Scott McCloud offers this bit of wisdom: "Don't think of them as backgrounds! These are environments—the places your characters exist within, not just backdrops to throw behind them as an afterthought."

The map of Camp Calicone, drawn by Jon Chad

Let's Go!

Cindy
Goal: to enforce the camp rules

Bryan
Goal: to have fun

1. Try drawing a comic story using the location as your catalyst. Take a look at the map of our fictional summer camp, Camp Calicone. Select two locations on the map, but don't pick two locations that are right next to each other.

2. Now that you know your setting, let's add some characters. Above are our two leading roles. I've indicated their appearance, their names, and their goals in the story. You make up the rest, and feel free to draw them in your own style.

3. Pencil and ink a one-page comic that starts in one of the locations you picked, and ends in the other. Refer to your map to learn what they'll pass by or pass through on their journey. Don't forget to work the characters' goals into the story, and play them off of each other.

4. How did the map inform your storytelling? Try mapping out the location of a story that you've made in a previous lab or one that's still living inside your head.

Talking Heads

Materials

- a variety of paper (at least three different colors)
- ruler
- circle template
- pencil
- scissors
- glue stick
- pen

Tip

The moment it takes the reader to figure out who said what, that's a moment the reader is not immersed in the act of reading

Action is important in a story, but in most comics there is a point where the plot needs to be delivered by dialogue only, a.k.a. talking heads. Visually, this can get pretty boring. One way to break up the monotony is to vary the "camera angles." Eddie Campbell's feet rule comes in handy here (turn back to Lab 13 for a refresher).

Another rule to keep in mind is one we borrow from film: the 180-degree rule. When filming, the camera should stay on one side of the action—if the camera is rotated more than 180 degrees from its previous location, a character on the right side of the screen is suddenly on the left. If a character was running across the screen toward the right, he is now returning back to the left. Confused? So is the audience.

The details of the 180-degree rule are hard to follow (especially when your "camera" is only conceptual), but the gist of it is this: you need to maintain the left-to-right orientation of your characters between panels. If you have two or more characters in a panel and character 1 is on the left, she can't be on the right in the next panel. This movement would jar the reading experience and would likely confuse the reader—who might be halfway through reading the word balloon when he realizes the wrong character is speaking. The moment it takes the reader to figure out who said what, that's a moment the reader is not immersed in the act of reading.

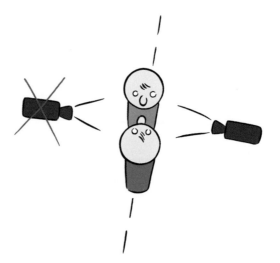

Let's Go!

A "talking heads" scene from my short comic, Turtle Pancakes. *This comic is all about talking, and there is very little action. I try to keep it interesting by gradually moving the "camera," staying well within my 180 degrees.*

1. On a piece of paper create a three-tier page layout (any layout is fine, except a democratic grid).
2. Gather together some different colored paper (construction paper or origami paper works well).
3. Using your circle template, trace several circles of varying sizes onto one of your sheets of paper.
4. Cut out the circles, and don't worry if you don't cut perfectly.

5. Cut out several rectangles of varying sizes using another color of paper. Take your third color and repeat this step, but this time make triangles.
6. Create two characters by combining a circle (for the head) and either a rectangle or a triangle (for the bodies). Use your glue stick to paste your characters into the grid. Don't worry about a story, but do think about design. Make sure you vary your camera shots and don't break the 180-degree rule.
7. Use your pen to draw simple faces on your characters—just a few lines to distinguish who they are and how their bodies are positioned. Also add some word balloons, but don't add words.
8. Look at your page. What kind of story does it suggest? Are you eager to learn more about these characters?

LAB 28 No People

Materials

- notebook paper
- pencil
- eraser
- bristol board
- inking tool of your choice

"Graphic stories are able to show incidental life without having to describe it."

—Alison Bechdel

Almost all stories are populated by people (or characters of some sort). In their absence a story takes on a completely different shape. You'll probably find that panels without people in them are better suited for stories about setting rather than character.

A story without characters lacks action, which tends to slow the pacing way down, perhaps creating a dreamlike, timeless feel. This approach benefits stories that are less about plot and more about reflection or setting a certain mood.

It's hard to maintain a reader's interest if you attempt this approach throughout a 160-page graphic novel, but in short amounts, it can create a vivid and intimate type of story. There are pitfalls, though. Your aim should always be to make comics, and not "illustrated text." What's the difference? To put it simply, illustrated text feels "dead" when you read it. The words and the images feel like distinct entities, or redundant ones (the rule of show OR tell applies here, as ever; see Lab 19). Another rookie mistake is to have the text run too long, overpowering the image.

Let's Go!

1. Select one of the comics you've made in a previous lab.
2. Consider how you could tell that same story without people or characters of any kind. What will fill your panels? Consider these options:
 - Draw the environment your story takes place in; move through it and show it from various viewpoints.
 - Focus on certain aspects of your environment, giving them a close-up.
 - Consider how objects can stand in for characters.
 - Use your environment to show the passage of time.
3. Take your notebook paper and work out your story. Select the narration for each panel and scribble down the images that will accompany it.
4. Pencil out your comic on bristol board, and follow up with inks.

Opposite Page:
An example from my comic Sourpuss, *in which a character discounts common myths about living in Alaska.*

Right: *From* King-Cat Comics & Stories *by John Porcellino*

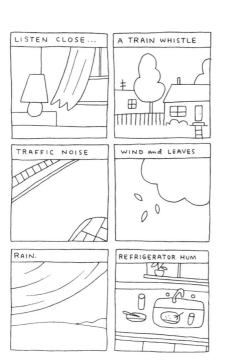

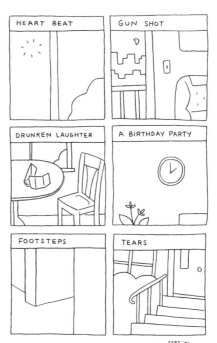

Found Text

- bristol board
- pencil
- pen
- found text (optional)

Have you ever found an old letter on the sidewalk or a diary in the trash? I have (the key is to always look down). A piece of found text can be very loaded, charged as much by the secrets it shares as the ones it keeps. Who wrote these words? Who were they written for? And most important, how did this note get abandoned on the sidewalk?

Found text offers a glimpse into a stranger's life, but that glimpse is dim and out of focus. It's only natural that it can suggest stories.

Tip

Go hunting for found text at antique stores and flea markets. I found the postcards in this lab at an antique store for twenty-five cents each.

Let's Go!

1. If you have a piece of found text stored away, use it for this exercise. If not, use the postcard above. Read the text. You will create a comic using those words, exactly as they're written. You don't have to use all the text, but whatever you use must be an exact quotation.

2. Create a page layout with any number of panels (even if that number is one).

3. Use your text to create captions or word balloons for your panels. Place your text before you draw.

4. Draw your story based on the text, either illustrating what the words say or merely what they suggest.

By Grace Lu

Tips of the Trade

If you haven't been lucky enough to stumble on some found text, pick up an issue of *Found Magazine* (or visit www.found magazine.com). *Found* has a seemingly endless collection of found notes, art, stories, and letters. You might also have some luck at a thrift store or flea market. I found the postcards in this lab, complete with personal messages, at an antique store for twenty-five cents each. A found image can sometimes work as well as found text. Look for old photographs and yearbooks and let them suggest stories and characters.

LAB 30 The 24-Hour Comic

- bristol board
- pencil
- eraser
- inking tool of your choice
- a comfortable place to work
- food, water, and snacks
- caffeine

"It's fun, it's exciting, it's mind-altering, it'll teach you all kinds of cool stuff about yourself and best of all, it's only one day, so what have you got to lose?"

—Scott McCloud

A DAY'S WORK
BY SCOTT McCLOUD

The 24-hour comic is another innovation from Scott McCloud, who invented the challenge in 1990 (read about its history and official rules on www.scottmccloud.com). It was originally proposed as a dare to his buddy Steve Bissette (see Lab 38), who was notoriously late in turning in his pencils for the comic *Swamp Thing*. As Steve puts it, "It took me five weeks to pencil a monthly comic book. Do the math."

The dare was this: create a twenty-four page comic in 24 hours. It was only fair that Scott take the challenge, too. Scott completed the first 24-hour comic on August 31, 1990, and a week later Steve completed the second. The 24-hour comic grew into a phenomenon as more well-known cartoonists took on the challenge.

Some cartoonists swear by the 24-hour comic as a life-changing experience; others write it off as a simple endurance exercise that results in lackluster, unpublishable work. I'm of a mind that every cartoonist should do it at least once and consider it a rite of passage. It's true that the resulting comic will probably not be publishable in a traditional sense, but you can't walk away from the experience unchanged. My one (and only) 24-hour comic was sparse and crudely drawn, but the story surprised me (pleasantly so). I was left with a sense of accomplishment and pride, and twenty-four pages of comics that I never knew I had in me.

Above: *The cover and first page of* A Day's Work, *the first-ever 24-hour comic by Scott McCloud*

Let's Go!

A few pages from my own 24-hour comic

1. Gather up all the materials you'll need to conceive, pencil, letter, and ink a comic. Also plan to have some meals prepared and some snacks handy (be sure to have plenty of healthy snacks, but also have some junk food and caffeine for emergency purposes). Once the clock starts, it doesn't stop, not even to run errands or eat.

2. Plan a 24-hour period that you can devote to comics, and only comics. I followed the example set by Alec Longstreth, who follows a midnight-to-midnight schedule (he's been making 24-hour comics annually for more than a decade!). The nice thing about this schedule is that you get to watch the sun rise and set, which can help you pace your progress. And when you finish your final page at midnight, you can go right to sleep and be back to normal the next day!

3. Be sure to have a peaceful, low-activity day before starting a 24-hour comic. Make sure you have a full night's sleep (or a long nap at least) before the clock starts.

4. Twenty-four hours means twenty-four hours: no preliminary work can be done beforehand. The story, art, lettering, and even proofreading must be completed within those twenty-four hours. Don't come to the exercise with a preconceived plan, though you can have a general theme or story prompt in mind.

5. Start your clock, and draw at least one page an hour. Try to finish your pages early so you can have a 5- to 10-minute break each hour. You'll need these breaks to eat, go to the bathroom, and stretch your legs.

6. When you finish your last page congratulate yourself, and go right to sleep! If you're in a group setting, get a friend to take you home. Don't drive home!

7. So you didn't finish? It's not the end of the world! There are two "noble failure" endings, named for the authors who first did them. If you call it quits after twenty-four hours but don't have twenty-four pages, that's the "Gaiman Variation" (named for Neil Gaiman). If you reach twenty-four hours and you're not done, but you keep on going until you've finished, that's the "Eastman Variation" (named for Kevin Eastman).

Tips of the Trade

Consider whether you'd like to do your 24-hour comic solo or in a group setting. Both methods have their benefits. A group setting will make the event more social, and your peers can help you soldier through. There is a downside, though—if one of your group members caves in and quits (which is likely to happen) it gives you an easy out. Personally, I've had much better results with the solo route: I can do it in the comfort of my own home, in my pajama pants, on any day that works for me.

Materials and Techniques

WHEN CARTOONISTS FIRST START to learn about their craft, the second question they usually ask is what tools they should buy (the first question being, "How do you make any money doing this?"). Tools are important, but they don't make the cartoonist. A certain variety of brush or a certain brand of ink won't magically produce beautiful drawings. However, finding the right tool for your drawing style will go a long way toward making your drawings the best they can be.

The following labs are designed around the tools most commonly used by cartoonists, but it is not an exhaustive list. Really, anything that can make a mark on paper is a possible art supply. I've read some wonderful comics that were painted, sketched, stamped, collaged, and cross-stitched. Let's start with the basics and see where that takes us.

UNIT 4

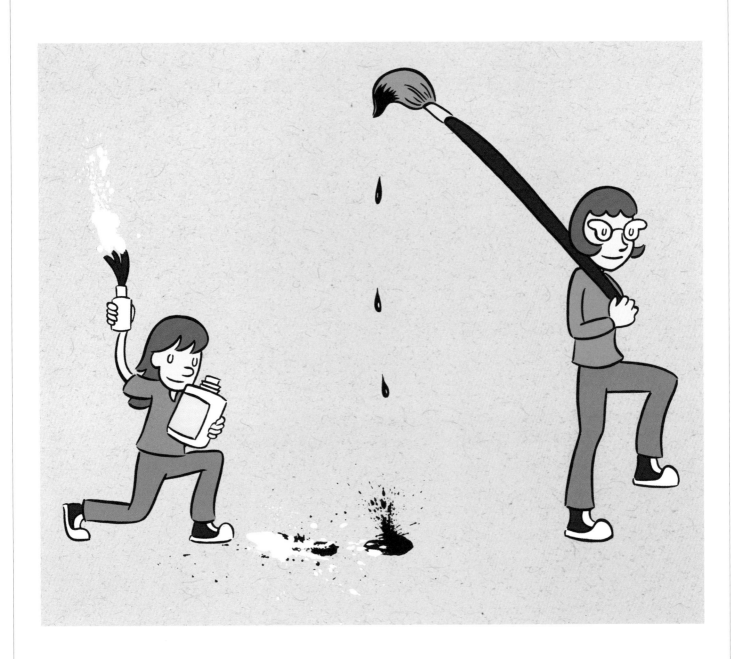

LAB 31 Comics Morgue

- digital camera
- computer with an Internet connection
- magazines, catalogs, or newspapers
- pencil
- bristol board

"Never draw anything you can copy, never copy anything you can trace, never trace anything you can cut out and paste up."

—Wally Wood

Cartoonists need to know how to draw just about everything, and nearly all cartoonists use photo references at some point. Some even keep a "morgue," or a collection of reference images. The term comes from the early days of comics, when morgues were filled with "swipes," or comic panels that were "borrowed" and redrawn by another cartoonist. A morgue might also be filled with clippings from catalogs, magazines, newspapers, or even reference photos taken by the cartoonist.

Since the advent of the Internet, traditional morgues are considered by many to be obsolete. While I agree that Internet image searches are incredibly useful, I still think there's value in keeping a reference file. For example, I've always had trouble drawing hands and arms, especially the way they fall to your side when you are standing at ease. Over the years I've collected a lot of images of hands and arms from catalogs and magazines. It's handy (no pun intended) to have these images at the ready, and a Google image search for "hands, the way they fall to your side when you are standing at ease" doesn't return much that is useful.

Sometimes, you can't find just what you're looking for, even on the Internet. This is when the digital camera becomes an indispensable tool. If you can find a friend or two to pose for you, you can act out scenes from your comics and get just the angle you're looking for. Alison Bechdel used a digital camera to stage every panel in her best-selling graphic novel *Fun Home*.

Dennis Pacheco uses a combination of digital camera shots and online photo references to create his comics.

Let's Go!

1. Get your stick figure strip from Lab 11.

2. Redraw the strip using references. Use a digital camera to stage the action in your panels. If you have some friends handy, have them act out the scene. If not, you can set the timer on your camera and pose yourself.

3. Printing out your photos will take up valuable time, so try drawing directly from the camera's screen in the preview setting.

4. Use photo references from an Internet search or from a book, magazine, or other source to redraw the backgrounds. Do not trace the photo reference—you don't own it, so it would be inappropriate to copy the image exactly. Instead, use aspects of the photo, or multiple photos, to inform your backgrounds.

5. Compare this comic to one where you didn't use references. How do they compare? Does using references help or harm? The key is to let references inform your drawings, but not manipulate them. You should strive to use references in a way that's congruous with your drawing style, not to create a patina of photo-realism.

- smooth bristol board
- vellum bristol board
- pencil
- eraser
- pen
- paintbrush
- India ink

Many of these exercises have called for plain copy paper, which is fine for thumbnails, sketches, or quick exercises. When it's time to get serious and create comics meant for publication, you need a more professional drawing surface. The paper most used by cartoonists is bristol board. Bristol board is a heavy-weight paper made of multiple plies of paper bonded together (generally two-ply, though heavier weights are available). There are different grades of bristol, depending on the number of plies and the ratio of cotton fiber versus paper fiber. A higher number of plies and more cotton fiber make for better (and more expensive) bristol. Strathmore's 500 series, with its 100 percent cotton content, is one of the best (and most expensive) bristol papers available. Most cartoonists, and certainly beginning cartoonists, will find Strathmore's 300 and 400 to their liking and within their budget. Economy or student-grade bristol is also available and is of decent quality. No matter which paper you choose, it's a good idea to do some test inking before you begin penciling. Look for ink lines that bleed or spider. When applying wash, look for paper that will give you a consistent tone.

Tip

Brushes flow more quickly over a smooth surface, whereas a rougher surface will drag on your brush slightly. Only use vellum if you plan to take advantage of the toothiness of the surface.

Graphite scribbled on Strathmore Series 400 bristol: on the left is the smooth surface, on the right is the vellum

Two lines, made by a Hunt 102 nib on 400 Series Strathmore paper. The line on the left was made on a smooth surface, the one on the right on vellum. When it is enlarged 500 percent, you can see that the vellum surface makes for a slightly rougher line. It is more difficult to make a perfectly smooth line on vellum due to its toothiness and capacity to soak up ink.

Bristol is available in smooth or vellum (textured) surfaces. You can also find bristol with a plate surface, which is ultra-smooth, almost glasslike. Most of the cartoonists I know prefer a smooth surface—if you're a beginning inker, I recommend you start here. Whether you're using pen, nib, or brush, a smooth surface will give you a crisp line. Brushes flow more quickly over a smooth surface, whereas a rougher surface will drag on your brush slightly.

I would only recommend using vellum if you plan to take advantage of the toothiness of the surface. If you're looking for an ink line with a rougher edge, if you'll be using a dry brush effect, or if you're using graphite or an ink wash for shading, then vellum is the surface for you.

Let's Go!

1. Make a trip to your local art supply store. Bristol board is a common art supply used by many graphic artists, so it's likely that any well-stocked store would have a few varieties available.

2. Run your fingers over the paper surface, noting the difference between the smooth and the vellum surface. Purchase both a smooth and a vellum pad. Make sure the paper is labeled acid free or archival. At some art supply stores you can buy bristol by the sheet—in this case, buy a sheet of each.

3. Pencil two identical drawings of one of the characters you created in Lab 4.

4. Using your pen, ink your two drawings. If you're familiar with the nib or brush, use these tools as well (if not, don't worry—we'll get to those in a couple of pages).

5. Take note of these important factors:
 • Are your ink lines smooth and solid, or does the ink bleed or spider?
 • How well do your ink lines hold up to erasing?
 • Which paper feels "most right" as you're drawing and inking?
 • Which surface responds best to the way you hold and move your drawing tools?

6. Take your paintbrush and apply a thin wash (a mixture of ink and water) to the bristol. Is the tone consistent, or mottled?

7. How did your bristol board rate? If it didn't respond well, repeat these steps with another brand.

Penciling

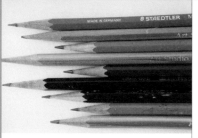

- pencils ranging from 4B to 4H
- a non-photo blue pencil
- a colored pencil
- bristol board
- light box

Drawing pencils come with graphite of varying hardness. Hard pencils make lighter lines, keep a sharp point for longer, and smudge little. Soft pencils make darker lines, dull quicker, and smudge easily. For this reason, I always tend toward the harder variety.

But how can you tell a hard pencil from a soft one? Look at the end of your pencil, and you'll probably see a number and a letter. The letter indicates whether it is a hard pencil or a soft one—hard pencils are marked with an H (for hard) and soft ones are marked B (for black). The number preceding the letter is the degree of hardness or softness; for example, a 9H is very hard and a 9B is very soft. In the very middle of the spectrum is the HB, which is about equivalent to a regular #2 pencil. And just to make things more confusing, there is also the rouge F pencil (stands for fine), which falls somewhere between an H and an HB.

"Cartooning is all about slouching and thinking. And often there's no payoff: the comics page, when you complete it, seems to have been there forever."

—John Hankiewicz

Left to right: Scribbles from 4H, 2H, HB, 2B, and 4B pencils.

Non-photo blue pencils get their name because they create marks that will not reproduce when photographed by stat cameras, saving cartoonists the step of erasing their pencils. What's a stat camera, you may ask? These large cameras were once commonly used to photograph comic pages, but digital scanners now play this role. Non-photo blue pencils still have their uses, though. A scanner will pick up the blue marks, but a little digital manipulation can easily erase them.

Some cartoonists use non-photo blue pencils to rough in their drawings, and then use a regular pencil to trace the "right" line from the jumble of blue scribbles. If you're a messy penciler, this saves some time at the inking stage, because you don't have to decide which line to ink. However, some inkers like to keep their pencils loose so they can do some share of the drawing in the inking stage.

Colored pencil can also come in handy when you're creating complex backgrounds with crisscrossing perspective lines. Try using different colors for perspective lines, background elements, and foreground elements.

Let's Go!

1. Select one the thumbnails you made in Lab 9, 13, or 17.
2. Recreate that page on your bristol board, drawing it at least twice as large.
3. Use at least two of these penciling techniques:
 • Non-photo blue pencil
 • Colored pencil
 • Light box

Tips of the Trade

If you are a truly messy penciler, like I am, you might find that you're tearing your bristol board to shreds by overdrawing and erasing. Try using a light box to transfer your messy pencils to a clean drawing surface. When using a light box, I recommend you make a photocopy of your pencils with the darkness increased to the max. It will be easier to trace this photocopy through a thick layer of bristol board.

34 Lettering

- Ames lettering guide
- sketchbook or bristol board
- T-square
- pencil
- pen
- eraser

Tips of the Trade

Uppercase text has been the industry standard for comic books since the early days, but lowercase letters are becoming increasingly common—it is sometimes considered a more literary approach. Either way is valid, though if you're using lowercase text you'll want to pencil in all three lines in the parenthesis set of your lettering guide.

The first rule about lettering is: plan ahead. Most of us are so eager to draw that we're tempted to leave the lettering step for last. If you consider your lettering only after the drawing is done, nine times out of ten you'll find you don't have enough room for your word balloons. Many cartoonists letter first, not last, to avoid this problem.

The next thing to consider is the rule of directional flow. We read the word balloons the same way we read our panels, left to right and top to bottom. If you aren't careful with your balloon placement, a character will answer a question before it has been asked. Nothing takes a reader out of the reading experience like broken lettering.

When drawing a conversation you also need to take into account where your characters are in the panel. The first word balloon needs to be on the left, and the character speaking should be close by. If that character is on the right, you might end up with crossed balloon tails. Crossed tails are an eyesore, and they're confusing. Take advice from the Ghostbusters: don't cross the beams!

We read word balloons from left to right and from top to bottom

Crossed tails are an eyesore, and they're confusing.

Let's Go!

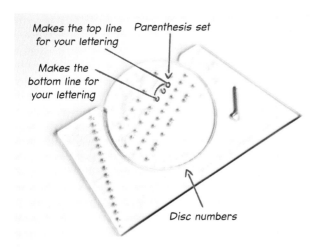

Ames lettering guide

Now that you have the fundamentals of lettering down, let's talk shop. To letter at a consistent size in perfectly parallel lines you'll need to lay down some guidelines. You could do this with just a ruler, but its difficult to be consistent and precise. There is a cheap drafting tool that can help you with this: the Ames lettering guide. The lettering guide can be tricky to master on your own, and the long and complicated instructions that come with it don't help much. This lab will lead you through the basic steps for using it.

1. Take out your lettering guide. In the center is an adjustable disc. Along the edge of that disc you'll see that it's marked 2 through 10. The larger the number, the larger the lettering. Rotate the disc so the number 4 is aligned with the tick mark at the bottom of the lettering guide's frame.

2. Grab a sketchbook or a pad of bristol board—because you will be using your T-square it's easiest to leave your paper in the pad. Take your T-square and place its head flush with the side of your pad, so it lies horizontally across your paper. Hold it in place.

3. Place your lettering guide on the top edge of your T-square and push it flush against that edge.

4. On your lettering guide there are four rows of holes; look for the bottom row marked "⅔." In that row you will see three sets of holes, with a parenthesis mark linking the top and bottom holes in a set. For lack of a better term, let's call those groups of holes parenthesis sets. Place the point of a hard, sharp pencil into the top hole of the first parenthesis set.

5. Move your pencil horizontally, keeping the guide flush against the T-square. The guide will move with you.

6. Take out your pencil, keeping the guide positioned on the T-square.

7. Place the tip of your pencil in the bottom hole of your first parenthesis set. Move your pencil horizontally again.

8. Repeat steps 4 through 7 two more times for the remaining parenthesis sets. In the end you will have three pairs of lines. Each pair has a line for the top of the lettering and one for the bottom. Each pair is separated by a thin margin. This is the key value of the lettering guide: not only does it make guidelines for the top and bottom of your lettering, but it also creates a margin for the space in between.

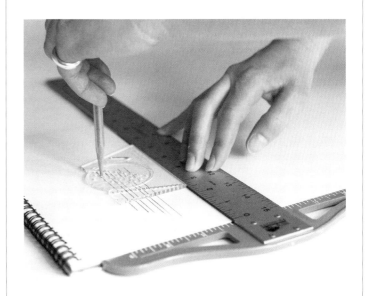

Pen Power

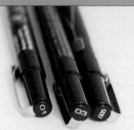

- smooth bristol board
- large and small porous-tip pens
- pencil
- eraser
- T-square

"Technical mastery of one's medium does not an artist make. The only quality you need is the ability to open yourself with honesty and pluck out the truth. Resolve to put the skills you do have to work now and pick up more along the way."

—James Kochalka

When you try out inking for the first time, you'll probably gravitate to pens first. They're the easiest inking tool to master, because you've been using pens of some sort all your life. They're also accessible and cheap—you can probably find a pen suitable for drawing at any office supply store.

There are two main types of pens you'll want to consider, technical pens (which are refillable) and porous-tip pens (which are usually disposable). Technical pens are expensive and require special upkeep, so I recommend first trying porous-tip pens (more commonly known as felt-tip pens). These pens are really closer to markers than they are to technical pens. You want the kind that are labeled archival, waterproof, lightfast, or fade proof. These terms don't always have clear-cut definitions, but they do indicate that a pen was designed to create lines that are durable and fade resistant. Faber-Castell Pitt pens, Staedtler pigment liners, and Micron pens (listed in my order of preference) all bear at least one of these terms on their labels.

Believe it or not, so-called permanent markers like Sharpies can fade over time (and they bleed a lot, too). There's a place for Sharpies in your tool kit, but don't use them as an everyday drawing tool.

The major limitation of pens is that they (excluding brush pens) cannot create a varied line weight in a single stroke. For this reason, few cartoonists use pens exclusively. Applying pressure to a brush or nib will result in a thicker line, but it will have little to no effect on a pen. To increase the thickness of your line, you need to change the size of your pen.

Let's Go!

1. Using the penciled pages you made in the previous lab, ink a page using pens. First, rule out your panel borders using your pen with the thickest line—if the panel border is a window to our comic, it makes sense that all other lines should recede from it. Use the penny ruler trick in Lab 12 to keep your panel borders from smearing.

2. Test out your pens to find a size that's right for lettering (not too thick, not too thin). Once you start lettering with a certain pen, keep with it until the end of the story so your lettering is consistent.

3. Ink your comic, switching between different pens for different tasks. Use your thicker pens to ink in objects in the foreground. Use a thinner line for objects in the background.

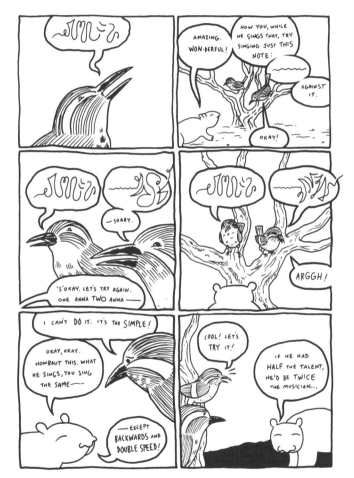

From True Swamp *by Jon Lewis. Jon used Pitt pens to ink this page, except for the large areas of black—those were filled in with a brush.*

Tips of the Trade

There are a variety of so-called brush pens on the market, some disposable and some refillable. They all have flexible tips, which can offer some variety in line width. The cheapest brush pens are the disposable ones with a brushlike felt tip, which can create an expressive (though often rough) line, while the most expensive brush pens are refillable and made with actual sable hair, just like a real brush. The Pentel Pocket Brush (both affordable and refillable) is a favorite among many cartoonists.

Inking with a Nib

Materials

- crow quill nib and holder
- India ink
- smooth bristol board
- photocopy machine
- copy paper or cardstock
- cup for water
- tracing vellum

photo by Michael Lopez

The nib offers both precision and versatility, which has made it a mainstay of the cartoonist's toolbox for more than a century! Because nib holders are held much like regular pens, the nib is often the first varsity-level inking tool new cartoonists try out. But as soon as you try to make your first mark, you'll notice that the nib is quite different from your standard pen. Nibmaster Jon Chad, another stellar faculty member from the Center for Cartoon Studies, has provided these tips and handy diagrams that will introduce you to this indispensable tool.

Take a close look at your nib. When you're inking, the top side will be visible. Keep it level while you're inking—letting the tip lean to either side will wear out the point.

"It's only lines on paper, folks!"
—R. Crumb

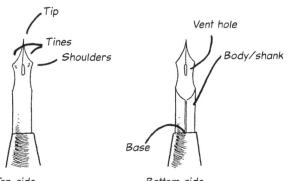

Tip
Tines
Shoulders
Top side

Vent hole
Body/shank
Base
Bottom side

Hold the nib holder just as you would a pencil or a pen. Be careful not to dip the pen too deep into your inkwell. Ink will get caught in the shank and it might flow out at unexpected moments.

Let's Go!

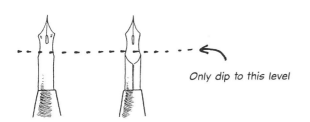

Only dip to this level

Place the nib on your drawing surface (smooth bristol works well). Apply downward pressure while pulling the nib (never push the nib). Apply greater downward pressure for thicker lines.

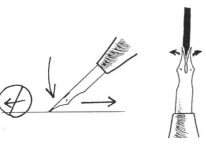

At right you'll find a panel from Jon Chad's comic *Bikeman*. Make a color photocopy of this page (preferably onto cardstock). Try inking Jon's page on your cardstock copy (do not draw in this book, especially if it's a library book!). You can also place a piece of tracing vellum over this page and ink that way.

Tips of the Trade

Over time nibs will wear out and need to be replaced. You can extend the life of your nib and the quality of your line by cleaning your nib with each use. Swish your nib around in clean water, but be careful it doesn't scrape the bottom of your cup. Dry it with a paper towel. Roll up a corner of your paper towel and dry the inside of the nib as well.

Inking with a Brush

- pencil
- vellum bristol board
- eraser
- sable brush, size 0 to 2
- cheap brush, size 4
- India ink

"To me, inking is sexy."

—Will Eisner

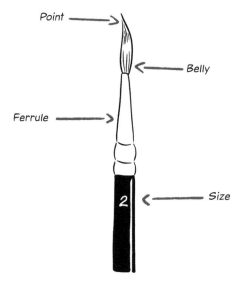

Hold your brush between your thumb and index finger, with the base of the ferrule resting on your middle finger.

The brush is considered by many cartoonists to be the gold standard inking tool—and I have to admit, I'm one of those cartoonists. The brush allows for a lot of line variety in a single stroke, something mechanical pens or even nibs can't touch. There is one caveat—mastering the brush is hard, and it takes time.

You hold a brush differently than you hold a pencil, and the way you move a brush is another story altogether. Although there is no one correct way to use the brush—whatever gets you the lines you want and doesn't damage your brush is correct for you—here are some tips that many cartoonists follow.

- Try to hold your brush as upright as possible—master inker Charles Burns holds his brush so it's almost perfectly vertical. Hold your brush between your thumb and index finger, with the base of the ferrule resting on your middle finger. Your wrist should be resting on the paper, and it is the pivot point for most of the strokes you will make. You should also try using your pinkie as a pivot point for small, precise strokes and tight circles. You'll need to use your whole arm, pivoting from the shoulder, to make long, straight lines.

- When dipping your brush in your inkwell, try not to dip past the top of the ferrule—ink tends to collect in the belly and on the edge of the ferrule, and it is difficult to clean it all out. Over time it will dry in the bristles and this will affect the point of your brush.

- Use the edge of your inkwell and a paper towel to brush the excess ink off your tip. Before you make a stroke, do some test strokes to ensure your brush has a nice point and isn't overloaded with ink or too dry.

- After several strokes you'll notice that your ink lines becomes rougher as your brush gets drier (this happens a lot quicker with vellum paper). You can use this dry brush effect to your advantage to create texture or shading. Dry brush is hard to control, so you'll want to practice it a lot before you apply it to your comic pages.

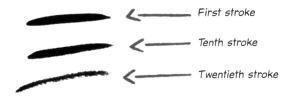

First stroke

Tenth stroke

Twentieth stroke

Tips of the Trade

The best brushes for inking are actually designed for watercolor. When shopping for a brush, look for a "round" watercolor brush made of sable fur. They come in a variety of sizes, and many cartoonists swear by a size 2 (though I use a size 0). The Winsor & Newton Series 7 is a clear favorite among cartoonists, though it is a pricey brush. To start with, you might want to try a cheaper sable brush, a synthetic sable brush, or a hybrid.

The most important part of the brush is the point—it needs to be sharp, without a single hair out of place. Before buying a brush, use this trick to test its point. Swish the brush in clean water (most art supplies stores keep water and paper out for testing brushes). Take the brush by its handle and flick it against your wrist. The excess water should fly off, leaving a perfect, sharp tip. If it doesn't, find a brush that will.

Let's Go!

1. Let's practice inking with a drawing that requires different types of brushstrokes. Get on the computer and search the Internet for a photo of a rooster (you can also use your imagination if you'd prefer).

2. Quickly sketch the rooster in light pencil on vellum bristol board.

3. Use a good-quality sable brush to ink the lines that make up the contour of its body, but not the tail, using thick strokes that pivot from your wrist.

4. Use that same brush to ink its eye, making a tiny circular stroke. This time, your weight should be resting on your pinkie. Remember to keep your brush vertical.

5. To ink the grass you'll use a dry brush effect. After dipping your brush, place the point against a paper towel to suck out the extra ink. Do a few test strokes, then make some long dry brushstrokes for the grass. Your wrist should be lying on the paper and movement will come from your shoulder—you'll be dragging your hand across the paper. Also create some short dry brush lines to add some feathers to the rooster's body.

6. The final strokes are for the rooster's tail. Find a larger brush, size 4 or larger. It should be a cheap, old brush without a point. Dip your brush, remove the excess ink, and do some test strokes— you're looking for a stroke with a slight dry brush effect. When you get the stroke you like, ink the tail.

Mixed-Media Inking

Materials

photo by Michael Lopez

Steve Bissette is a veteran cartoonist (and an instructor at the Center for Cartoon Studies) who has used a variety of inking techniques to make the moody and atmospheric horror comics he's known for. Some of his best tricks involve everyday items you might never have thought of using as art supplies. This demo will walk you through the process of inking falling rain and the night sky.

- 2- or 3-ply bristol board
- scissors
- crow quill nib and holder
- India ink
- variety of brushes
- single-edge razor blade
- bottle cap
- pencil
- opaque white or gouache
- jar lid
- toothbrush
- white correctional pen
- sponge

Steve's Inking Tips

"The following techniques are potentially messy! Be sure to let your ink dry completely between steps. When using these techniques, I always wear 'junk' clothes I don't care if I get ink or paint on and I cover any table or drawing surface with newspaper.

"Never throw out a brush—brushes that no longer have a proper drawing point are always useful for effects, textures, or laying down large areas of ink.

"The razor blade technique in this exercise only works on 2- or 3-ply bristol board or thicker illustration board. Never try this on single-ply paper! With a razor blade you can create white, broken lines almost impossible to do with white-out and a brush. The staccato, stuttering nature of the scraped lines really can simulate rain—or, applied differently in other circumstances, speed lines, fire, sparks, explosions, etc.

"When using a spatter effect you can mask an area with either a piece of paper taped into place (don't tape your illustration area, though) or weighted into place (with pen or heavy ruler), or by using professional self-adhesive frisket (a bit of overkill, though)."

Let's Go!

1. Cut out two pieces of 2- or 3-ply bristol board, each 3 inches (7.5 cm) square.

2. On your first piece of bristol board you will ink a night rain effect. With your pen nib, draw lines diagonally across your bristol. Strong, clear strokes are ideal.

3. Using a wide, beat-up brush, lay down some strong, thick strokes in the same diagonal direction as your nib lines.

4. Take your single-edge razor blade and match those diagonal strokes with firm, strong arm movements. Scrape with the edge of the blade; don't cut. With each scrape, some ink from the top surface of the paper will be removed. If you are unhappy with any of the white razor lines, black them out with ink and take another shot at scraping the white rain lines.

5. Grab your second piece of bristol board. Use a circular object (a bottle cap about 1 inch [2.5 cm] wide should be perfect) and trace around it in pencil. You've just penciled in the moon in a night sky.

6. Use a large brush to cover the rest of your bristol, except the moon, with ink.

7. Place a small quantity of opaque white (either Pro White, any brand of white-out, or even opaque acrylic paint or gouache) into a jar lid or a slightly concave surface. Mix in a small amount of water so your opaque white is liquid, but not thin or transparent.

8. Dip just one edge of your toothbrush into the small puddle of slightly diluted opaque white. Test your spatter on a piece of pre-inked or dark paper by running your thumb over the bristles, pointing the toothbrush down at your paper. Practice until you feel comfortable.

9. Use this "spatter" effect to create a fine pattern of stars. This is particularly excellent for creating the sort of fine Milky Way look often seen in a clear, crisp night sky. Allow the opaque white to dry before moving on to the next step.

10. Using a white correctional pen, or opaque white and a brush, dab just a few larger, single dots onto your star pattern. These create the appearance of larger stars, and provide a focal point for the Milky Way-like "spatter" star pattern. Allow the opaque white to dry completely.

11. Randomly choose two, no more than three, of your larger stars, and using either your white correctional pen or the opaque white and your brush, use just four strokes to create a four-point "cross" effect. Don't worry if they don't come out perfectly; once the opaque white dries, you can go back in with ink and sharpen those white points with your brush to precisely the shape you want.

12. To add some texture to your moon, use an ordinary household sponge (a new one; old sponges tend to get stinky). Your sponge will be over-saturated with ink, so dab the excess off onto a piece of scrap paper. You want just enough ink so the sponge leaves a nice crisp texture stamp. Once the desired texture appears, stamp it onto your moon.

50 Percent Black

- bristol board
- pencil
- eraser
- brush
- India ink
- other inking tools of your choice

Matt Madden is a cartoonist and comics educator who teaches at the School of Visual Arts. He also coedits (with his wife Jessica Abel, who gave us Lab 23) the prestigious *Best American Comics* series. In this lab he demonstrates the importance of "spotting your blacks"— that is, using black as a graphic tool to direct the eye, balance a page, or create visual dynamism.

Even if the brush isn't your inking tool of choice, be sure to use it to fill in large areas of black in this lab. No tool works better for making thick lines, quickly.

"When in doubt, black it out."
—Wally Wood

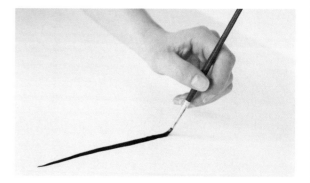

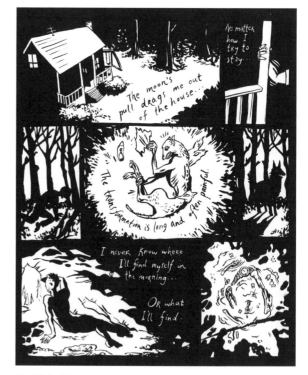

By Molly Ostertag

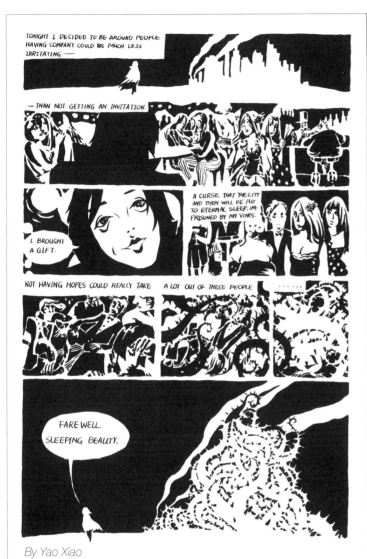

By Yao Xiao

Let's Go!

1. Select one of the comic pages you've created in the previous labs. Or, if you'd like to start from scratch, plan a new one-page story. You could try a genre that benefits from a dark atmosphere, like a horror or crime noir. Or, for an added challenge, you can create a story that wouldn't ordinarily be drawn with heavy blacks.

2. Pencil your page, and take a step back to look at it. Where should you spot your blacks? Consider placing blacks to create atmosphere, suggest lighting, direct the eye, or create a visually interesting composition.

3. Once you've decided which areas you'd like to fill in with black, mark them with a small X using a light pencil. This is a common penciling trick, and it works better than scribbling large areas of graphite on your paper. That wastes time and it keeps ink from absorbing into your paper correctly.

4. Ink your page, making sure you cover at least 50 percent of it in black.

Matt's Tips for Using Black

"Black is a powerful graphic and narrative tool for cartoonists, yet many artists are timid about splashing it on the page—especially when they're starting out. I like to force my students to grapple with black by assigning them a one-page comic where the finished page must be at least 50 percent covered in black. The comic must tell a story—it's not just a visual exercise, but one where I want students to engage with the way black spotting can be used to create a mood and guide the eye across the page. The need for so much black on the page suggests a story that will be dark in both its setting and its atmosphere, though I encourage students to resist the obvious—a student once drew a comic about a polar bear hiding in a cave. On the visual side, using so much black forces students to think about lighting, composition, and the overall design of the page. I also like how it teaches them to draw shapes and use negative space, and to decrease their dependence on the outline."

Playing with Tone and Color

- pencil
- watercolor paper
- watercolor paints
- watercolor palette or a few bottle caps
- clean brush, not used for inking
- paper towels
- brush for inking
- India ink
- scanner and computer with Adobe Photoshop (optional)

Most of the exercises in this book will prompt you to use black ink on white paper only, with no shades of gray. There are two reasons for this: black-and-white line art reproduces well, and it reproduces cheaply. For the beginning cartoonist, it's best to think in black and white; to focus on line, negative space, and the spotting of black. Once you're comfortable with that, try playing around with tone.

When you create art using pencil or an ink wash, you create what is called continuous tone—a tone that modulates from light to dark, with many shades in between. It's important to understand that photocopiers and professional offset presses cannot produce a continuous tone, though they can fake it. These printing technologies use hundreds of tiny dots, called a halftone screen, to simulate shades of gray.

The key to making a continuous tone reproduce well is having a high level of contrast in your image. Make sure your grays aren't too light or too dark. A good balance between your spotting of blacks and negative space will make your image more readable and reproducible. It's much easier to control the contrast if you're using a computer program like Adobe Photoshop—in fact, I'd say it's a necessity if you plan to create an ambitious comics project with continuous tones. If you're looking for a cheaper and more accessible way to control your grays, use the brightness and contrast settings on a photocopier.

At some point, you'll probably want to experiment with color, too. Printed color is a combination of cyan, magenta, yellow, and black ink, or CMYK. The K doesn't stand for black but for *key*, meaning all other inks are keyed to that ink layer. When Jason Little's full-color comic *Shutterbug Follies* was first being published in alternative newspapers, Jason offered the strip in a variety of color schemes.

A halftone, enlarged several times

HB woodless pencil

Ink wash

Computer

Jason's Color-Mixing Tips

Figure A

Figure B

Figure C

Figure D

"Figure A is full-color CMYK process printing. Figure B is the same image converted into one ink—black. Note that a straight conversion from CMYK to grayscale yields a slightly unsatisfying low-contrast image. So I have tweaked the Photoshop levels, pushing the lightest grays to white, and darkening the darkest grays further. Figure C is a simulated two-ink setup, designed to look as though printed with a very dark blue ink and a red ink. I've used Photoshop's Channel Mixer Adjustment here. I sent all the yellow data to the magenta channel, and all the cyan data to the black channel. Then I replaced black with a dark blue, and magenta with a candy apple red, which yields decent skin tones when screened at a low percentage.

"Figure D is a simulated three-ink setup, designed to look as though printed with a very dark blue, yellow, and magenta. Here the blue does double duty; at full strength it makes dark lines, but at lighter screens it behaves like a low-saturation blue. So we get almost a full range of colors, but greens, blues, and purples won't be as vibrant as they would in a true CMYK treatment.

"Photoshop's Channel Mixer is a fascinating tool. Rather than give you recipes here (which would look like Rubik's Cube instructions), I recommend you run some of your own CMYK images through Channel Mixer and experiment."

Let's Go!

Jason has devised a really good system for mixing color in Photoshop, but let's try a more hands-on approach.

1. Quickly sketch a portrait of yourself in a light pencil on watercolor paper.

2. Take your watercolor set and mix a very dilute shade of red in your palette or in an empty bottle cap. Use the margins of your watercolor paper to test out your color.

3. Once you have a light shade of pink, remove the excess water from your brush by making several strokes on your paper. You want your brush to be pretty dry, so it's almost, but not quite, creating a dry brush effect.

4. Color in the lighter parts of your face—the lightest parts of your drawing should be left blank, so the white of the paper shows through. Use a dry brush effect to create a feathered transition from dark to light.

5. Wash out your brush and create a nice dark blue shade. Again, remove the excess water from your brush. Lay in blue in the darkest parts of the drawing (but not on top of your red paint). Use a dry brush effect to create a feathered transition from dark to light.

6. Give your watercolor a chance to dry, then start layering pink on top of blue (and vice versa). Once again, use a very dry brush. A new color is made by layering transparent shades of paint, rather than blending pigments together. This process is similar in concept to how CMYK printing is done.

7. Once your paint has dried, ink the lines of your drawing. You're adding the key layer, the one that traps the color to make a discernible image.

Tag Team

- notebook paper
- pencil
- eraser
- inking tool of your choice
- India ink
- bristol
- timer
- 2 cartoonists

Tip

Whatever your goal is as a cartoonist, whether you want to work independently or collaborate in the traditional industry, it's important to understand each step of the cartooning process.

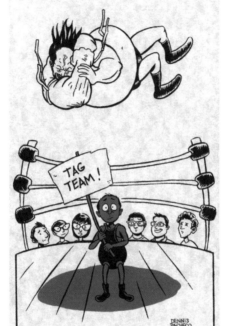

In the early days, the comic book industry depended on the division of labor to produce a large number of comics on a monthly schedule. The same holds true today for certain parts of the comics industry—at the graphic novel publishing house I work at, a book might have a writer, a penciller, an inker, a letterer and a colorist assigned to it (not to mention an editor, a proof reader, a graphic designer, a publicist ... the list goes on and on).

Whatever your goal is as a cartoonist, whether you want to work independently or collaborate in the traditional industry, it's important to understand each step of the cartooning process. The following collaborative exercise developed by Dennis Pacheco offers an excellent crash course in those steps.

Dennis is an independent cartoonist whose love of superhero comics led him to develop the Tag Team exercise. This exercise produces what he described as "a sweat-shop style comics anthology with an indie vibe." Dennis divided the cartooning process into six steps: story synopsis, plot, thumbnails, lettering and panel borders, pencils, and inks. He then invited six cartoonists to join him in a comics making marathon: together they would produce six short comics, twenty-four pages total, in just twelve hours. They would achieve this feat by each completing one step of each comic and working on a tight schedule. My version of the Tag Team exercise is a bit more abbreviated, requiring just four steps, three people, and producing nine pages total.

Above: by Dennis Pacheco

Let's Go!

1. Find two cartoonists who want to collaborate on a nine-page comic project and can commit the time necessary. Schedule a time a place to meet and draw for five hours.

2. Establish a story prompt that all your comics will share. If you're stumped, try this one: a bus pass, good for 30 days. Your story doesn't have to be about the prompt, but the prompt must be present in some way.

3. Before you meet, everyone has a homework assignment—set your timer for fifteen minutes and write out a basic story synopsis using your prompt. It should be three to five sentences (no more) and give a sense of what the story will be about. Set the scene, describe the conflict, and suggest a resolution. Make your story brief enough that it can be told in three pages.

4. Meet your fellow cartoonists for your drawing marathon. Be sure to have food available and plan to take short breaks between your work sessions. If possible, work together at a large table or arrange your desks in a circle.

5. Hand your synopsis to the person on your left, take a synopsis from the person on your right. Set your timer for an hour and turn that synopsis into three pages of thumbnails. You can add details, expand on ideas, or change the direction of the story.

6. After an hour, pass your thumbnails and the accompanying synopsis to the left. Take your new thumbnails and synopsis from the person on your right. Set the clock for two hours and turn those thumbnails into pencils. Be sure to pencil in the lettering, too. Again you can expand or change the story somewhat (but keep these changes small, you'll need every spare minute to draw!).

7. After two hours, pass your synopsis, thumbnails, and pencils to the left—you should be getting the story you originally plotted from the person on your right. Set the clock for two hours and start inking. At this point make no story changes, though you can make slight stylistic changes to the art.

8. At the end of your drawing marathon, take time to read every story and talk about the process. Get pizza to celebrate!

A page from Labor. *I wrote a basic story synopsis, Colleen Frakes turned that into a detailed plot, Morgan Pielli drew the thumbnails, Sam Carbaugh lettered and ruled the panel borders, Dennis Pacheco penciled the story, and Pat Barrett did the inking.*

Publishing

THE COMICS PAGE WAS MEANT to be reproduced and shared; this is part of its DNA. As you draw your comics, you need to think of them, even visualize them, in terms of a publication—and you should do this before you start drawing, not after. Knowing how your comics will be published will help you determine how, and at what size, to draw your pages.

But what if you don't have a publishing company waiting to produce your next masterpiece? Then you'll start out like most of us do: you'll be your own publisher. It might sound difficult, but it's not. Anyone can self-publish; all you need is a little know-how and access to a photocopy machine (and trust me, they're everywhere!).

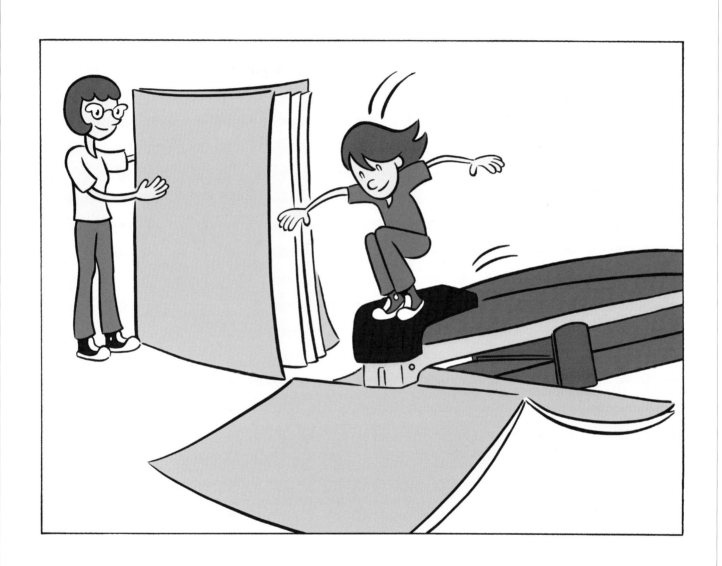

Make a Dummy

- letter-size paper
- pencil
- colored pencil

"Don't be a dummy, make a dummy!"

—Alec Longstreth

Regardless of its size, a comic that is self-published and handmade is called a minicomic. The term comes from the late 1970s, when a photojournalist turned publisher named Clay Geerdes started printing these tiny comics by the hundreds. With the use of a photocopy machine, a relatively new technology at the time, he made double-sided 8½ × 11-inch (21.6 × 28 cm) photocopies and then cut them in half and folded them to create quarter-size pages.

Today, minicomics come in all shapes and sizes. Some are still assembled from black-and-white photocopies, and some are elaborately screen printed and hand bound. In this lab we'll explore some simple DIY (do-it-yourself) publishing techniques. It's easy to get started, but first you need a basic understanding of pagination.

When we read a comic book, the pages have been assembled so one comes after another in a logical sequence. This all seems very simple when the book is bound, but if we take it apart, things get complicated. Take, for example, this eight-page booklet.

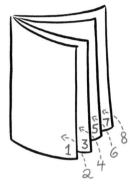 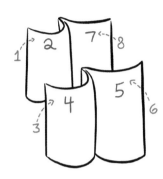

When the booklet is unbound, suddenly page 1 is opposite page 8, page 2 is opposite page 7, and page 3 is opposite page 6. Only the center spread seems to make sense: page 4 remains opposite to page 5. What a mess! But if you want to make a minicomic, you need to learn how to navigate this mess.

There's probably a mathematical formula that will tell you exactly how to paginate your book, but if there is I don't know it. Pagination is so tricky, it's better to ignore your brain and use your hands. By making a dummy book you can ensure that your pagination will come out right every time.

You may be tempted to try a professional design programs such as InDesign or Quark to lay out your minicomic, but try the "old school" cut-and-paste method first. It's always better to learn something by hand with tangible materials before attempting it with a computer. Your brain can better understand something if you can hold it in your hands, turn it over, and take it apart. Not to mention, the cut-and-paste method is more accessible and cheaper by several hundred dollars!

Let's Go!

1. Fold two pieces of letter-size paper in half, hamburger style (see Tips of the Trade, below). Nestle one of the folded papers inside the other. What you have will resemble an (unbound) eight-page booklet—this is your dummy. Because a single piece of folded paper results in four pages, a minicomic with a standard binding will always have a page count in multiples of four.

2. With a pencil, number each page, 1 through 8. Make your page numbers big and bold, easy to recognize at a glance. If you do it correctly it will match the diagram on the far left.

3. Select some work from the previous labs and plan a minicomic that is eight pages long exactly (including a front and a back cover).

4. Using your colored pencil, note on your dummy what will go on each page of your minicomic. Make these notes at the top of your dummy page. This placement, and the color of your pencil, will keep you from confusing your notes with the page number of your dummy.

Tips of the Trade

Hamburger style, hot dog style, what are we talking about? It can be hard to describe, through words only, something as simple as folding a piece of paper in half. So I've borrowed the terms used by many a kindergarten teacher. Folding paper hamburger style results is a short, squat rectangle, and folding it hot dog style results in a long skinny one.

Make a Mini

- your dummy from Lab 42
- letter-size paper
- proportion wheel
- photocopy machine
- scissors
- glue stick
- long-reach stapler

"Self-publishing is a great place to hone your skills and burn off your art school delusions."

—Carla Speed McNeil

The great thing about minicomics is they're cheap, easy, and accessible. Anyone with a pocket full of change and a self-serve copy machine (and they are everywhere!) can make a minicomic. As Kurt Wolfgang so colorfully put it in *Understanding the Horrible Truth About Reinventing Mini Comics*, making minicomics is so easy that a drunken man could draw, print, and distribute one long before he had the chance to sober up and regret it. That's what I call an art form for the everyman.

Once you have your dummy book made, the next step is to paste up the master copies, the copies from which all subsequent copies will be made. In this DIY method, your master copies will be made of photocopies themselves, meaning the final product is a copy of a copy. Yes, this will cause degradation in quality. In the future you can avoid this by using a computer program that allows you to print directly from a digital file.

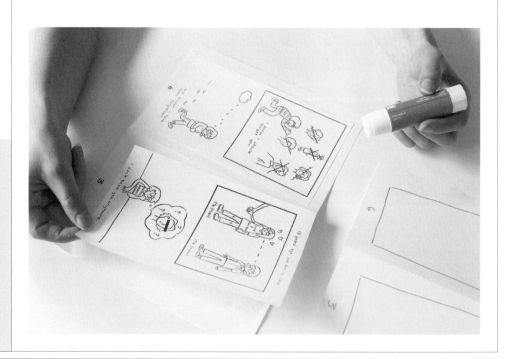

Let's Go!

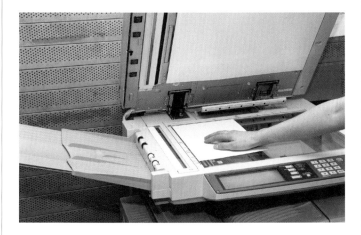

1. Grab your dummy. Take the first folded page spread and lay it flat so the page 8/page 1 side is facing up.

2. Take a letter-size paper and fold it in half carefully, then flatten it out. You will use this to paste up your master copy.

3. Grab the comic pages that will go on your page 8/page 1 spread. Using your proportion wheel (see Lab 10), determine the amount of reduction required to make your artwork fit on a 5½ × 8½-inch (14 × 21.6 cm) page.

4. Use a photocopy machine to reduce your artwork to the required size.

5. Take your photocopied reductions, trim them down, and paste them onto your master copy so they match the page 8/page 1 spread of your dummy.

6. Repeat these steps until you've pasted up all four of your master copies.

7. Take your first two master copies (page 8/page 1 and page 2/page 7). Using the double-sided setting on the photocopier, make one double-sided copy of these two masters (ALWAYS make one test copy before you make a bunch). Are both pages right side up? Does your pagination match your dummy?

8. Make a double-sided copy for the remaining master copies (page 3/page 6 and page 4/page 5).

9. Fold your two photocopies in half and nestle one inside the other, just like your dummy. You have made your minicomic, now you just need to bind it.

10. Grab your long-reach stapler. Set the paper guide to 5½ inches (14 cm).

11. Unfold your minicomic and lay it flat, cover side up. Place it under the long-reach stapler so one of the outer edges is flush with the paper stop. The spine of your book should fall under the head of the stapler. Staple twice through the spine, one staple near the top of the book, the other near the bottom. It may take a while to perfect your aim with the long-reach stapler.

12. Did your minicomic come out right? If so, make several more copies. Leave a few unbound, because we'll use them in another lab.

Tips of the Trade

DIY publishing doesn't require much, and most of the supplies you'll need can be found in a well-stocked office. There is, however, one specialty tool you'll need to invest in: a long-reach stapler. This stapler has a very long body, which allows you to fit your whole comic underneath it so you can staple through its spine. This kind of binding is called the saddle stitch, and it's a common minicomic binding method because it's simple, quick, and cheap. A good long-reach stapler will cost you between twenty and thirty bucks, but it's a sound investment. My Stanley Bostitch is still going strong after a decade of use.

Design as Content

- notebook paper or a sketchbook
- pencil

"It's important to make something that's thrilling. A minicomic, with the right color of paper, the right staples, the right distance apart, the right way to ink, and a little stack of them on your table, can just be totally thrilling."

—Gary Panter

Many cartoonists treat book design as if it were wrapping paper to be applied quickly to what really matters: your comics, your content. I look at it in a different way. I believe design is content. Before your audience ever reads your stories, they will first interact with your book as an object. These first impressions matter. The way you design your book will inform your reader about your story, and it can even enhance the reading experience. So you can judge a book by its cover, if it's a comic book.

Even for the DIY publisher on a limited budget, there are a lot of design options available to you. You can control the shape of your book, the size of it, and the color and texture of your paper. And, of course, you have to consider what goes on the cover: what art, what text, which font, which color. With all those options it's easy to get overwhelmed. The key is not to worry about making "good" design choices; instead, try to make appropriate design choices.

I think John Porcellino's *King-Cat Comics & Stories* (see image above) is just about the best minicomic of all time. Let's take a closer look at it: it's made of letter paper folded in half hamburger style, the most basic minicomic size. Its pages are white; its cover is white. Both the cover and the interior are made up of black-and-white photocopies. As minicomics go, it's just about as basic as you can get. That's not bad design, that's *appropriate* design. John's comics are deeply personal and spiritual, perhaps the best example of comics poetry you'll ever find. The drawings are minimalistic and created with a simple uniform line. It makes sense that his book design would be simple and balanced as well, with no bells and whistles. Don't confuse good design with complicated, expensive, or elaborate design. Always ask yourself, what's the right design for this book?

The theme of my zine Hey, 4-Eyes! *is eyeglasses.*

The lunch anthology

The theme of my zine *Hey, 4-Eyes!* is eyeglasses, which I tried to incorporate into every aspect of the book design. The book even came with a pair of paper glasses, tucked into a library pocket. The comic anthology shown above was made at a cartooning workshop I co-taught with Tom Hart. We started the anthology right after our lunch break, which inspired our book design. The anthology has a horizontal orientation, designed to look like a sandwich. We found some paper lunch bags to package our comic in. We even used part of our lunch in the printing process—we made a stamp from an apple. Let this be a lesson: good DIY book design is partly based on good ideas, and the rest is improvised by what you have at hand.

Let's Go!

1. Select one of the comic stories you've made (this can be one that's completed or uncompleted). Try to envision how that comic would be transformed into a published book. Make notes of your ideas.

2. Consider the shape and size of your book: what kind of books benefit from being big? Which ones benefit from being small? Horizontal? Vertical? Triangle shaped? What's best for your story?

3. What color should your interior pages be? Most books have white interior pages, but any light color can work (cream is my favorite color for interior pages).

4. What kind of paper should you use for your cover? Your cover should generally be made of a thicker stock than your interiors; look for paper labeled cover stock or cardstock. Be wary on construction paper, because its color is not lightfast and it wasn't designed to go through a copy machine.

5. Sketch out some book designs based on your ideas.

Tips of the Trade

Photocopy machines are designed to take three standard paper sizes: letter (8½ × 11 inches [21.6 3 28 cm]), legal (8½ × 14 inches [21.6 × 35.6 cm]), and tabloid (11 × 17 inches [28 × 43 cm]). The standard minicomic sizes are made by folding these papers in half hamburger style.

These are not the only page sizes available to you, however. By folding hot dog style rather than hamburger style, you get a very different page shape. And with a paper cutter any of these pages can be trimmed down to all sorts of shapes and sizes.

The Foldy

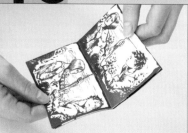

- letter-size copy paper
- pencil
- eraser
- inking tool of your choice
- photocopy machine

Now that you know some DIY publishing basics let's explore some simple publishing forms. The foldy is about as simple as it gets—it requires only a single sheet of paper, and no cutting or binding. It's unclear exactly who invented the foldy. Kenan Rubenstein stumbled on the idea while he was working as a receptionist, when he had plenty of time and office supplies on hand. "I'm not so arrogant as to believe no one ever thought of this before," says Kenan. "I'm just not aware of anyone who did."

About the same time, Jon Chad (see Lab 36) stumbled onto the idea and was creating his own foldy, *Whaletown*. As Jon puts it, "I think Kenan and I were like two grizzly mountain men inventors who independently invented the steam engine up in our respective mountain retreats." Since then other cartoonists have caught on.

A foldy is made by taking a single sheet of paper and folding it four times, making five "pages" (including the cover). These pages are revealed as one unfolds the book. If this sounds confusing, don't worry—this will become clearer once you start folding according to the diagram.

The foldy is a unique book, if it can be called a book at all. It has no binding, and pages are not turned in the standard way. With each unfolding the page does two things: it doubles in size and it changes in orientation (from vertical to horizontal, or vice versa). These changes can be used to your advantage (remember, design IS content!). What type of story benefits from a page that grows with each turn? How can changing the orientation of the page affect your storytelling?

Page 2

Page 1

Back cover

Front cover

Page 3

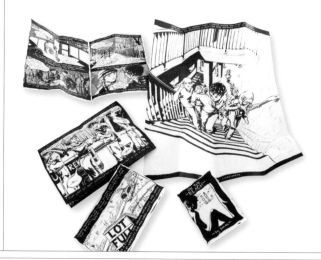

An assortment of foldies by Kenan Rubenstein. Kenan also created the foldy instructions on the opposite page.

Let's Go!

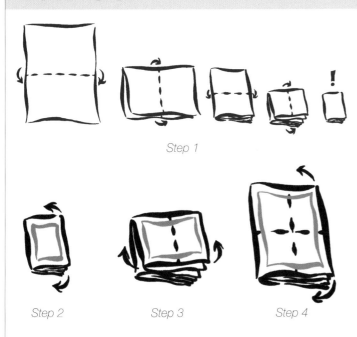

Step 1

Step 2 Step 3 Step 4

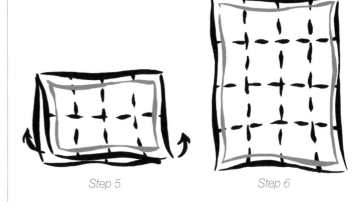

Step 5 Step 6

1. Fold a piece of letter-size copy paper in half four times, as shown above.

2. Draw your first page, which is actually your front and back cover.

3. Open to page 2. This fold mimics the way a book is usually bound, so this page turn will come naturally to your reader. Notice that the page now has a horizontal orientation. Draw your second page. Because these pages are so small, consider drawing only one panel per page.

4. Open to page 3 by pulling the outer page upward. A top-edge binding like this is called a calendar binding. Your reader will be used to calendars and books that are bound this way, so this page turn will come fairly naturally. Draw your third page, which is now in a vertical orientation.

5. Do another regular page turn to open to page 4. This will have a horizontal orientation. Draw your fourth page.

6. Pull the outer page up, calendar style, to reveal the fifth and final page. This vertical page will take up the whole reverse side of your foldy. Consider how you can take advantage of this large splash panel. Draw your fifth page.

7. Make a double-sided copy of your foldy. Fold it up and give it to a friend!

Tips of the Trade

This lab had you draw your foldy directly onto copy paper. But what if you'd like to draw on bristol board, or draw at a larger size? First fold a piece of copy paper four times as shown in step one. Unfold your paper, then trace and label each page segment. Enlarge your paper on a photocopy machine, resizing it to a comfortable drawing size. Then carefully trace the page segments onto your bristol board, remembering to also trace the edge of your paper. Use a second piece of bristol board for the fifth and final page.

The One-Sheet

- letter-size paper
- pencil
- scissors or a craft knife
- eraser
- inking tool of your choice

"Don't forget about the back side of your new one-sheet. It's a great space for a poster or even more comics!"

—Beth Hetland

photo by Nate Beaty

Let's explore a popular and simple book form known as the hidden book, or the one-sheet. Like the foldy, this is a form of instant publishing. Follow these steps and you'll be able to fold and bind an eight-page comic with a single piece of paper.

Beth Hetland is a cartoonist and bookmaker who teaches at the School of the Art Institute of Chicago. She's a big fan of one-sheets—she makes them, collects them, and teaches her students about them. Follow her instructions and handy diagrams, and soon you'll be making your own one-sheet comic!

Let's Go!

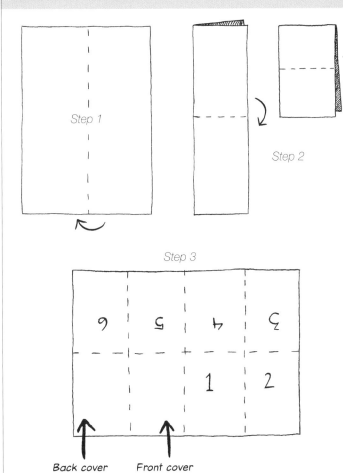

Step 1

Step 2

Step 3

Back cover Front cover

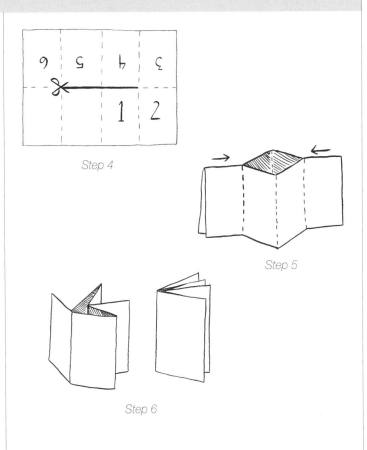

Step 4

Step 5

Step 6

1. Take your copy paper and fold it in half, hot dog style, so you have a tall skinny rectangle.

2. Fold your paper in half again, this time hamburger style, so you have a short, squat rectangle. Then fold it in half again, hamburger style.

3. Unfold your page. You will see you folded the paper into eight segments. These segments are your six pages, plus a front and a back cover. Place a small page number on each segment.

4. Use a craft knife or scissors to cut a slit along the center line of the middle segments.

5. Fold the paper in half, hot dog style. Pinch the two outer pages by the corner, right before where the center slit starts. Bring these two corners together.

6. The book will appear magically before your eyes! Draw a front and a back cover, and fill the pages with comics. Because of its small size, you may want to draw just one panel on each page.

You can make multiple copies of your comic by unfolding it, making a photocopy, and folding that copy using the same steps.

ABC Zine

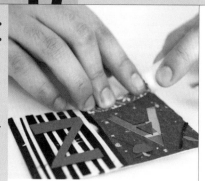

- letter-size cardstock
- ruler
- variety of papers and paper scraps
- variety of art supplies
- glue stick
- color photocopy machine
- scissors or a craft knife
- stapler

Pen and ink are the trusty tools that cartoonists have relied on for more than a century to create reproducible comic art. In the past couple of decades the quality of printing and photocopying technology has improved, and digital publishing has become more prevalent. It is now easier and cheaper to produce comics using a whole range of media.

José-Luis Olivares is a cartoonist who is more comfortable holding a graphite stick than a pen nib. He likes to make comics that are spontaneous and a little messy. Chalk, glitter paint, sparkly stickers, and highlighters are just a few of his art supplies. The ABC zine is a fun and quick publishing project that José-Luis invented to challenge cartoonists to play with different media.

For this exercise, gather any art supply that will make a mark or any material that can be pasted onto a piece of paper. Find a comfortable space where you can get a little messy.

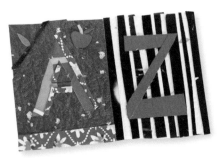

From First Flower, *a mixed-media comic by José-Luis Olivares*

Let's Go!

Back cover	Front cover	Your name	Date
32	1	30	3
Y 28	B 5	W 26	D 7
U 24	F 9	S 22	H 11
Q 20	J 13	O 18	L 15

A 4	Z 29	Inside front cover 2	Inside back cover 31
E 8	V 25	C 6	X 27
I 12	R 21	G 10	T 23
M 16	N 17	K 14	P 19

1. Take two pieces of letter-size cardstock. Use your ruler to divide the pages into sixteenths—each sixteenth will be a page of your zine. Or, instead of creating the template yourself, you can enlarge the template in this book with a photocopier.

2. Make sure both pages align perfectly. Hold the pages to a bright light, back to back, to make sure the borders align.

3. Use mixed media to create an alphabet letter on each page of your template. Also create a design for the outer covers, the inner covers, the name page, and the date page. Don't include the page numbers—they are just on the template for your reference.

4. Use a color photocopy machine to make a double-sided copy. Carefully trim your copy into eighths. Fold each eighth in half and put your pages in the right order.

5. Use a stapler to staple through the spine of your pages.

48

Creative Printing

- photocopy machine
- scissors
- glue stick
- letter-size paper
- letter-size cardstock
- tracing vellum
- pencil
- craft knife
- cutting mat
- rubber brayer
- stamp pad (any color except black)
- paper plate
- spray paint (any color except black)
- cardboard

As a self-publisher, your number one printing tool will probably be a black-and-white photo-copy machine. That's fine for the interior pages, but how do you spruce up the cover? The quick and easy option is to spend a little extra and make a color copy, but this gets expensive and lacks a handcrafted touch. Do not despair: you have a variety of DIY multicolor printing techniques to choose from. All of these hands-on techniques are labor-intensive, so it's recommended that you save them for the cover only—though if you're really ambitious, you could try printing your whole book by hand!

A. *This Isn't Working* edited by Robyn Chapman, brayer and stamp pad stencil on pink paper—Because it's transparent, tracing vellum can be handy for stencils—you can easily place your print in the right spot on your page. In this case, I printed the stencil on top of a photocopy, creating a two-color look. There is a downside to tracing vellum, though—it's not sturdy and will break down over time.

B. *Cry-baby* by Robyn Chapman, two-color screen print on pink paper—Screen printing, also known as silk screening, is a versatile multicolor printing technique. An image is made by passing ink through a stencil that has been embedded into a silk screen. The process is too complicated to cover here, though you can learn the basics in an afternoon. Many cartoonists have made it their DIY printing technique of choice because it's fairly simple and fairly cheap, and when done correctly the process can create vibrant, colorful, and clear prints.

C. *Rematch* by JP Coovert, full-color sticker on navy paper—This is what I call the old sticker trick. Rather than pay the price of a color copy for each cover, JP has printed several full-color stickers on a single sheet of sticker paper. Sticker paper can be purchased at any good office supply store; look for the kind that comes in letter-size labels and is designed to go through a color copy machine.

D. *Hey, 4-Eyes! #1* edited by Robyn Chapman, spray paint stencil on blue paper—The method behind the spray paint stencils is pretty simple. You need a can of spray paint, something to spray it on, and something to block the paint. It's not a controlled technique, but that can be part of its appeal.

E. *Tramp Stamp* by José-Luis Olivares, rubber block print on brown paper—José-Luis used Speedball rubber blocks to print this minicomic, basically carving his own rubber stamp. The rubber blocks are very easy to cut and carve—sometimes too easy; you have to be careful not to cut too much. It's a subtractive process: the negative space is carved away, leaving a raised rubber surface that will create your print. You have to think backward, because your carving will appear in reverse when you print it.

Let's Go!

Step 5 *The finished covers*

1. Select and photocopy a few drawings and comics from some previous labs. Cut up these copies and create a collage on a piece of horizontally oriented, letter-size paper.

2. Make several copies of your collage on letter-size cardstock.

3. Take one of your cardstock covers and place a piece of tracing vellum over it. Select an area where you'd like to add a spot color. Trace that color shape onto your tracing vellum with a pencil—it should be a simple shape and no wider than your rubber brayer.

4. Use your craft knife and a cutting mat (or a piece of cardboard, if you don't have a cutting mat) to cut out the color shape you drew in the tracing vellum. This will leave a hole in the vellum that will act as a stencil.

5. Roll your rubber brayer across your ink pad, covering it with ink. Align your tracing vellum over your cardstock cover and hold the vellum in place. Roll the brayer across your stencil hole.

6. Take your cover, paper plate, spray paint, and cardboard to an outdoor area where you can work comfortably. Don't use spray paint indoors!

7. Lay down the cardboard to protect the ground from paint. Place one of your covers on the cardboard and select the areas you want to mask from the spray paint. Cover this area with your paper plate. Spray your cover, keeping the can parallel to the paper while moving it back and forth in smooth movements. Use a light touch on the nozzle.

LAB 49 Creative Binding

Materials

For Tape Binding:

- letter-size copy paper
- paper cutter
- letter-size cardstock
- binder clip
- stapler
- kraft tape or duct tape
- scissors

For Thread Binding:

- letter-size copy paper
- letter-size cardstock
- bone folder or spoon
- cardboard
- ruler
- thumbtack
- large sewing needle
- embroidery floss
- scissors

Binding with the long-reach stapler is quick, easy, and efficient. As a self-publisher, it should be your go-to binding method (see Lab 43). It does have its limitations, though. It's difficult to bind a minicomic that is more than eighty pages; the stapler just wasn't designed to bind a stack of paper that thick. Also, a saddle stitch can look a little plain, mechanical, and boring. What if you want a binding method that's more colorful and handcrafted? The possibilities are nearly endless!

Bookbinding is an art unto itself, and some serious bookbinders take days to bind a single book. As cartoonists, we should be more concerned with publishing than making fine art objects, so we need not be so precious. The following methods are quick, simple, and cheap, and can be done with everyday supplies you probably have around the house.

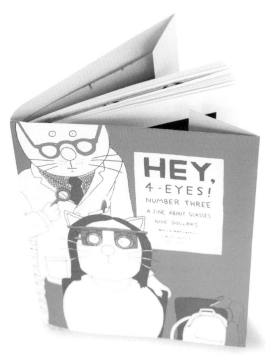

French flaps are extended paperback covers that have been folded back. This variation on the French flap results in an outer book cover that is a lot like a dust jacket. It's easy to do; just bind a book with a saddle stitch as usual, and fold a larger piece of cardstock around your cover. The French flaps will hold the outer cover in place.

Let's Go!

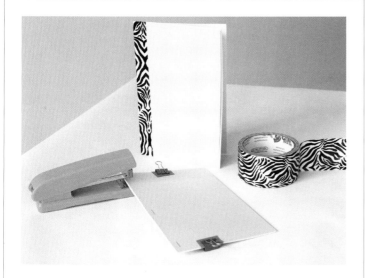

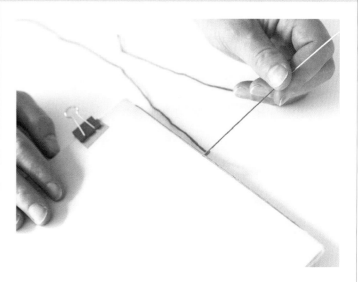

1. This first binding method is a quick and dirty imitation of square binding, the type of binding you see on graphic novels. With this method you can bind a very long book together, especially if you use a heavy-duty stapler. To start, grab a stack of letter-size paper, about six pages. Cut the stack in half.

2. Cut a letter-size piece of cardstock in half. Sandwich your stack of copy paper between the cardstock, carefully aligning the edges. Use your binder clip to hold the stack together. Binder clips can have a very tight pinch that can leave little bite marks in your book, so use a scrap of paper to cushion the bite.

3. Place three staples through the stack near the edge of the spine. Put a staple at the top, one at the bottom, and one in the center.

4. Get a roll of kraft or duct tape (look for brands that come in different colors or patterns). Cut off a piece that is as long as the spine of your paper stack. Place the tape over the spine and adhere it to your book covers.

1. This next method is a variation on Japanese stab binding. Start with a stack of 8½ × 11-inch (21.6 × 28 cm) paper, about ten sheets, and fold it in half, hamburger style. Take a sheet of letter-size cardstock, fold it in half with a bone folder or spoon, and nestle the pages inside so you have an unbound book.

2. Lay the book flat, cover side up, on a piece of cardboard. Take out your thumbtack and make three holes in the spine: one ½ inch (1.3 cm) from the top (hole A), one in the dead center (hole B), and one ½ inch (1.3 cm) from the bottom (hole C).

3. Thread your needle with a long piece of embroidery floss, but don't knot your thread or double it up. Thread your needle through the spine as follows, each time going through the hole and out the other side: through hole B, up and through hole A, down to the bottom and through hole C, up the center and through hole B.

4. Pull your thread taut and tie off the loose ends in hole B. snip off the extra thread, but don't snip too close—a little bit of tassel looks classy.

Living the Dream

FOR MANY OF US, THE DREAM MEANS MAKING A LIVING, possibly a good one, from drawing comics. That dream does come true—for a small number of people. The rest of us need to build a counter narrative to The Dream. For the past seven years, I've worked in what can vaguely be called the comics industry—as an administrator, a teacher, an editor, a publisher, a project manager, and now an author. If I had waited around for that comics drawing job I would have long since starved.

So, am I disqualified as being professional? Hardly. All being a professional means is that you take cartooning seriously and approach it with an industrious work ethic. With a little effort and a bit of guidance, we can all be professionals, and each fashion a version of The Dream to our personal trajectories.

Go to a Comics Convention

Materials

Materials

- tablecloth
- 2 bar clamps
- 1 piece of PVC pipe, 1 foot (30 cm) long
- 1 piece of PVC pipe, 2.5 feet (76 cm) long
- foam core of cardboard
- masking tape
- a stack of your minicomics

Tip

Being a member of the comics community is key to sticking with comics in the long run.

Comics conventions are great places to promote your work and network with professionals. But more important, they are a great place to make friends. Establishing long friendships with like-minded peers will keep you happy and sane during those long, lonely hours at the drawing table. Most likely, you will find that you and your peers inspire each other to produce your best work. Being a member of the comics community is key to sticking with comics in the long run.

You may have already gone to a comics convention as an attendee. Take it to the next level by going as an exhibitor. Hundreds of conventions are held across the country each year. The ones that will be most accessible to you are the small press or indie conventions. The largest of the small press conventions (the Small Press Expo, the Museum of Comic and Cartoon Art Fest, and the Alternative Press Expo) attract exhibitors from all over the country. Registration fees are high and waiting lists can be long. Although I do recommend these conventions, it's also worth investigating the small regional conventions in your area. These are often one-day events held in collaboration with local colleges or businesses. These shows welcome beginners and registration fees are usually low.

photo by Sarah Smith

Let's Go!

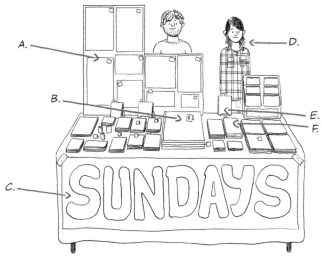

An ideal table, front view. Art by Chuck Forsman

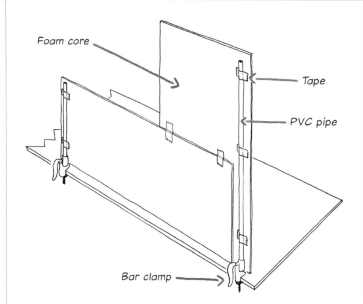

An ideal table, back view. Art by Chuck Forsman

Once you've registered at a convention table, you need to plan how you will display and sell your work. Convention tables are usually 6 feet (183 cm) long, which may be more space than you need. You can split your table with friends, or purchase a half table.

A. Create an upright display to maximize your table area. Upright displays hide the mess you will usually find behind the convention table. They also offer an attractive backdrop for your comics.

B. Mark all your prices clearly. Customers may be hesitant to ask about the prices of items.

C. Always bring a tablecloth; it will offer you a good place to hang a sign. You can store extra inventory under the table, out of sight.

D. Make this your motto: "Sitters do not sell." Standing keeps you at eye level with your customers and invites them to interact with you.

E. Book stands are another type of upright display worth investing in. Behind these stands you can hide pens, sketchbooks, or a cash box.

F. Keep your inventory well stocked. No one wants to buy your last copy.

1. Cover the table with a tablecloth. Position your bar clamps on each end of the table, in the back, with the bar sticking up.

2. Put your PVC pipes over the clamps, so that the bar is inserted inside the pipe. This will keep the bar in an upright position.

3. Using the PVC pipes as a support, tape a piece of foam core or stiff cardboard to the pipes. The bottom of the foam core should rest on the table.

4. Display your comics by resting them against the foam core.

Materials

- notepad or sketchbook
- computer with a word-processing program

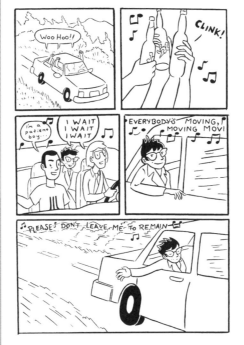

If you ever decide to be a member of an artist/writer creative team, a comic script will be an essential tool. There's another reason to be familiar with the basics of script writing—most major publishers will expect to see, and edit, a comic script before the first panel is drawn.

When it comes to script writing, many cartoonists are overly concerned with the topic of formatting. There isn't too much you need to know about script formatting, except that a comic script looks a lot like a screenplay. Far more import than having a professionally formatted script is having one that is written with clarity and efficiency. Your job is to describe the pictures in your head so a third party can understand it.

Robyn's Tips for Writing Scripts

Only describe what will actually be drawn. Don't create a backstory that only exists in your script. If it's not going to be on your comic page in some tangible way, it doesn't belong in your script.

Don't think about your panel as if you were looking through a viewfinder on a movie camera. Pretend that you're taking a snapshot. Remember, nothing really moves in a comic. Movement can only be suggested.

LIMIT. YOUR. TEXT.

Writers often crowd their scripts with captions and word balloons. Dialogue and captions take up tangible real estate in your panel, probably more than you realize. Comics are a form of haiku; less is more.

Let's Go!

1. Choose one of the comics you created in a previous lab. Be sure to pick one that is at least three pages long.

2. Adapt your comic pages into a comic script. Yes, this is reverse engineering, but it's also a great way to start thinking about how to use words to describe images. Follow the basic format provided in the example.

3. Look at your script. Did it take more than one page of text to describe one page of comics? Then you're probably being overly elaborate. Make an effort to use as few words as possible without losing meaning and clarity.

Sample Script

A. *Include the title and page number at the top of each page or in the header.*

B. *You will need to include character descriptions somewhere in your script. You can either include a list of character descriptions in your preface or you can describe characters as they appear in your story.*

C. *Be sure to include all sound effects (SFX is a handy abbreviation).*

D. *Any text within brackets will not actually end up on your comic page. Using brackets is a way to send a note to your editor: musical notes will appear on this comic page, but not the words "music notes."*

E. *It's typical to have character names in capital letters; this formatting is borrowed from theatrical scripts. Feel free to use it, or not.*

F. *Keep your panel descriptions brief and clear, or the meaning of your image will be lost in the details. Only in panel 5 did I mention the panel size, because a large panel is essential for this moment.*

A → **Page 6 of *Sourpuss*, Issue #2**

Panel 1:

B → Extreme long shot of a beat-up Datsun driving down an Alaskan country road. Doris, Sinclair, and Jason have raised their fists out the car windows in a celebratory salute.

ALL: Woo hoo!!

Panel 2:

A close shot of three hands as they each raise a bottle of Jolt Cola in a toast.

C → BOTTLE SFX: CLINK!

D → RADIO SFX: [music notes]

Panel 3:

Pull back to show the three seated in the interior of the car. Jason drives, Sinclair is shotgun, Doris is in the back. They are happily singing along to Fugazi's "Waiting Room," which is playing on the tape deck.

E → SINCLAIR: I'm a patient boy ...

DORIS and JASON: I WAIT, I WAIT, I WAIT

RADIO SFX: [music notes]

Panel 4:

From outside the car we see Doris leaning out the car window. She is smiling, having a happy moment to herself.

RADIO: [music notes] EVERYBODY'S MOVING, EVERYBODY'S MOVING, MOVING, MOVING [panel borders crop some song lyrics]

Panel 5:

F → A large panel, taking up the bottom tier. We have pulled back from the previous shot. Doris has extended her hand, she is letting the wind zip through her fingers and blow her hair. The background blurs as the car speeds on. Her eyes are closed, her smile is gone, she is having a Zen moment.

RADIO SFX: [music notes] PLEASE DON'T LEAVE ME TO REMAIN

Write a Proposal

- computer with a word-processing program
- access to the Internet

"I scrutinize my writing like it's a legal document before I let it go."

—Eddie Campbell

For many of us, the big dream is to land a book deal with a major trade publisher. Imagine, not only would they publish your graphic novel and send it off to bookstores all over the country, but they'd pay you for it, too! It's a good dream and it does happen, now more than ever. But being a published author, or a working artist of any kind, is never easy and rarely comfortable. Most of my friends are cartoonists, and most of them have a day job or a financially supportive spouse (or both)—even the ones with book deals. Even the really famous ones.

But don't despair! If you create truly inspired work, and a lot of it, someone is bound to notice—and that someone might be a publisher. If you want to sell them your book, then you need to speak their language, and that means preparing a book proposal.

Carol Burrell is a cartoonist and the editorial director of Graphic Universe, a graphic novel imprint. Many proposals have passed across her desk over the years, and she's offered to share some pointers and walk you through building a proposal, step by step.

Let's Go!

1. Write a cover letter: a brief explanation of what you are submitting (one sentence will do!), a brief discussion of your bibliography or qualifications, and a pleasant sign-off. If you have an online following—a strong one—or if you're interested in illustrating projects written by others or writing scripts for other artists, state so here.

2. Write the executive summary, or one short paragraph describing the project and the main character(s). This is akin to the "elevator pitch." Imagine you have 30 seconds in an elevator with a high-powered editor. What can you say about your project in that time?

3. Write the long synopsis. This should be about one page, but you can fill this one and spill over to another. Now you can go into detail about the beginning, development, and denouement of the plot, or spell out the events chapter by chapter.

4. This step is optional, but consider including a page with character descriptions—who the pivotal characters are, what they want, and how they change over the course of the story.

5. You could stop at step 4 with some types of pitches. But the editor will want to make sure you can tell a story visually before investing the time to review more of your work. Consider including a sample scene: three to six pages of script or the equivalent in drawn pages—tight pencils at least, and, if you plan to do all the inking and lettering yourself, at least one example of a finished, lettered page.

Carol's Tips for Writing Proposals

"My first piece of advice for submitting a proposal is to check the publisher's website for submission guidelines. Then follow those guidelines and ignore everything else I'm about to say.

"However, if they don't have guidelines, and just to give you an idea of what to expect...

"Whether you're mailing your proposal, emailing a PDF, or dropping an envelope off at a booth at a convention, address the proposal to a specific person, if possible (Dear Jane Smith). If you can't find a name, Dear Creative Director or Dear Submissions Editor will do in a pinch. But you should be able to track down at least one actual human at any given company.

"Make it as simple as possible for the publishers to review your work and understand your idea, and from there you'll have a chance to convince them that you have the ability and consistency to follow through. If your work is already complete—for example, you're looking for a publisher for your webcomic—then you've already won the battle to prove your stick-to-it-iveness. On the downside, even though proof of a finished project makes an editor much more inclined to take an artist seriously, you might end up having to make a lot of changes, even to the point of being asked to redraw the first section of a comic that has evolved in style over time.

"It should go without saying that your proposal should be carefully proofread, but I'm going to say it: proofread your entire proposal and have someone else go over it, too.

"Finally: of course you want to send your best artwork—but make sure you send representative work. Don't send elaborately painted, detailed pages if you can't sustain that for the entire project. Don't promise more than you plan to deliver.

"All together, this is a proposal of about eight to twelve pages. Most publishers will know pretty quickly from this whether their list is a good home for your story."

Contributors

Jessica Abel
www.dw-wp.com

Josh Bayer
www.joshbayerart.com

Jonathan Bennett

Stephen R. Bissette
www.srbissette.com

Eddie Campbell

Sam Carbaugh
www.samcarbaugh.com

Isaac Cates
www.satisfactorycomics.blogspot.com

Jon Chad
www.jonchad.com

JP Coovert
www.jpcoovert.com

Vanessa Davis
www.spanielrage.com

Rachel Dukes
www.poseurink.com

Matt Feazell
www.cynicalman.com

Colleen Frakes
www.tragicrelief.com

Tom Hart
www.sequentialartistsworkshop.org

Beth Hetland
www.beth-hetland.com

Bill Kartalopoulos
www.on-panel.com

Seth Kushner
www.sethkushner.com

Jon Lewis
http://trueswamp.wordpress.com

Jason Little
www.beecomix.com

Michael Lopez
www.cargocollective.com/post_lopez

Grace Lu

Kara Lu

Jason Lutes

Matt Madden
www.dw-wp.com

Dakota McFadzean
http://blog.dakotamcfadzean.com

Scott McCloud
www.scottmccloud.com

Melissa Mendes
www.mmmendes.com

Tom O'Donnell
www.tpodonnell.tumblr.com

José-Luis Olivares
www.joseluisolivares.com

Molly Ostertag
www.monstertag.tumblr.com

Dennis Pacheco
www.pigeonholepress.net

Morgan Pielli
www.morganpielli.com

John Porcellino
www.king-cat.net

Jesse Reklaw
www.slowwave.com

Katherine Roy
www.caterpillarpublishing.com

Kenan Rubenstein
www.underthehaystack.net

Chris Schweizer
www.curiousoldlibrary.com

R. Sikoryak
www.rsikoryak.com

Sarah Smith
www.sasphotoimaging.com

Karen Sneider
www.metromonster.com

James Sturm

Drew Weing
www.drewweing.com

Mike Wenthe
www.satisfactorycomics.blogspot.com

Yao Xiao
www.yaoxiaoart.com

About the Author

Robyn Chapman is a publisher, cartoonist, and an educator. Her cartooning workshops have brought her to classrooms at the School of Visual Art, the New School, Wellesley College, and the University of Iowa. She spent five years at the Center for Cartoon Studies, initially as their first fellow and later as their program coordinator and a faculty member. During her time at CCS she earned her MFA, having previously earned her BFA at the Savannah College of Art and Design.

She is currently an assistant editor at Graphic Universe, the graphic novel imprint of Lerner Publishing Group. She also runs a mini-comics publishing house called Paper Rocket.

Acknowledgments

Many thanks to the following:

All of my amazing contributors: you're the best!

Rebecca Greenfield and Esme the cat

Everyone at the Center for Cartoon Studies, especially James Sturm, Michelle Ollie, Steve Bissette, Sarah Stewart Taylor, Jason Lutes, Alec Longstreth, Jon Chad and Valerie Fleisher

Joan Reilly and the Bridge Club Studio

Dennis Pacheco, my favorite copy editor

My tolerant and loving parents

A.W.P.

Nerd Club

Tom Hart

Lynda Barry

Carol Burrell

Harris Smith

The Savannah College of Art and Design

Mary Ann Hall and everyone at Quarry Books

All my teachers and all my students